# EDWARD BAWDEN
# IN THE MIDDLE EAST

Dear Joanna, & Richard,

One dark night a week ago I saw a rainbow. The moon was full & very bright, the rainbow was not over or around the moon but facing it, that is, I had to turn my back to the moon to see the rainbow. It was not brightly coloured as rainbows are in the daytime when the sun is shining, & the bow is seen against the black sheet of a cloud or rain-storm, but very pale & silvery. Rainbows at night are very rare, many people never see one, & that was the first I have seen myself, but I am told that if you go to the great Victoria Falls — which Mummy will show you on the map — you will often see a rainbow at night by the light of the moon.

I have been picking up from the beach some very pretty little cowrie shells. They are not easy to find. They are white & about as long as your middle finger. I found some other shells which I will bring home for you both.

I am writing this letter before breakfast, it is still dark. A donkey is braying in the street. I can hear a train. The newspaper boy is crying. Someone is walking down the passage outside my bedroom. Shall I ring for tea? If I do a black man will come with a small tray & small pot of tea. He will be wearing a long white nightshirt, & a little red flower-pot hat on his head. After he has brought the tea the newspaper boy will come. Then I shall have a bath, pack up my things, have breakfast, & go for a car as I have to do three hundred miles by tea time in the afternoon.

Dear Joanna, will you read this letter to Richard & give him my love. Give Mummy my love,
& love to yourself Daddie

# EDWARD BAWDEN
# IN THE MIDDLE EAST

NIGEL WEAVER

ROBIN O'NEILL

EDWARD BAWDEN

Antique Collectors' Club

British Library cataloguing-in-Publication Data
A catalogue record for this book is available from the British Library

Antique Collectors' Club
www.antiquecollectorsclub.com

Sandy Lane, Old Martlesham,
Woodbridge, Suffolk IP12 4SD, UK
Tel: 01394 389950 Fax: 01394 389999
Email: info@antique-acc.com
or
Eastworks, 116 Pleasant Street - Suite 18
Easthampton, MA 01027, USA
Tel: (413) 529 0861 Fax: (413) 529 0862
Email: sales@antiquecc.com

Published by Antique Collectors' Club, Woodbridge, England
Design by Webb & Webb Design Limited, London
Printed and bound in China

All the works illustrated in this book are in the Imperial War Museum, London or the
Government Art Collection, both of whom have agreed to allow reproduction; the
assistance of the Imperial War Museum and particularly Jenny Wood is acknowledged;
as is the helpful cooperation of the Edward Bawden Estate, and particularly Richard
Bawden. The Barbara Whatmore Charitable Trust made a grant that enabled Brian
Webb and Dan Smith of Webb & Webb to act as design consultants. Gordon Cummings
assisted in the preparation of manuscripts for publication, and Iris Weaver has provided
critical encouragement throughout. All royalties are being paid to the Fry Art Gallery
Society (Registered Charity 295904).

# CONTENTS

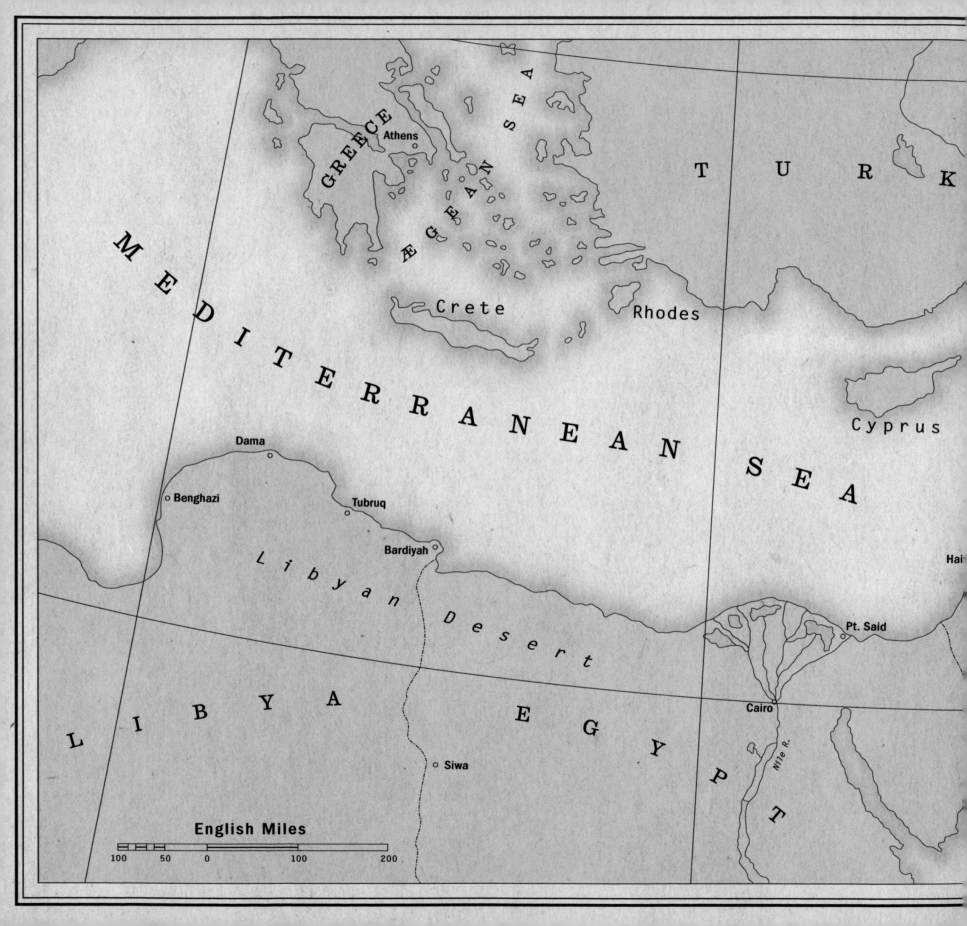

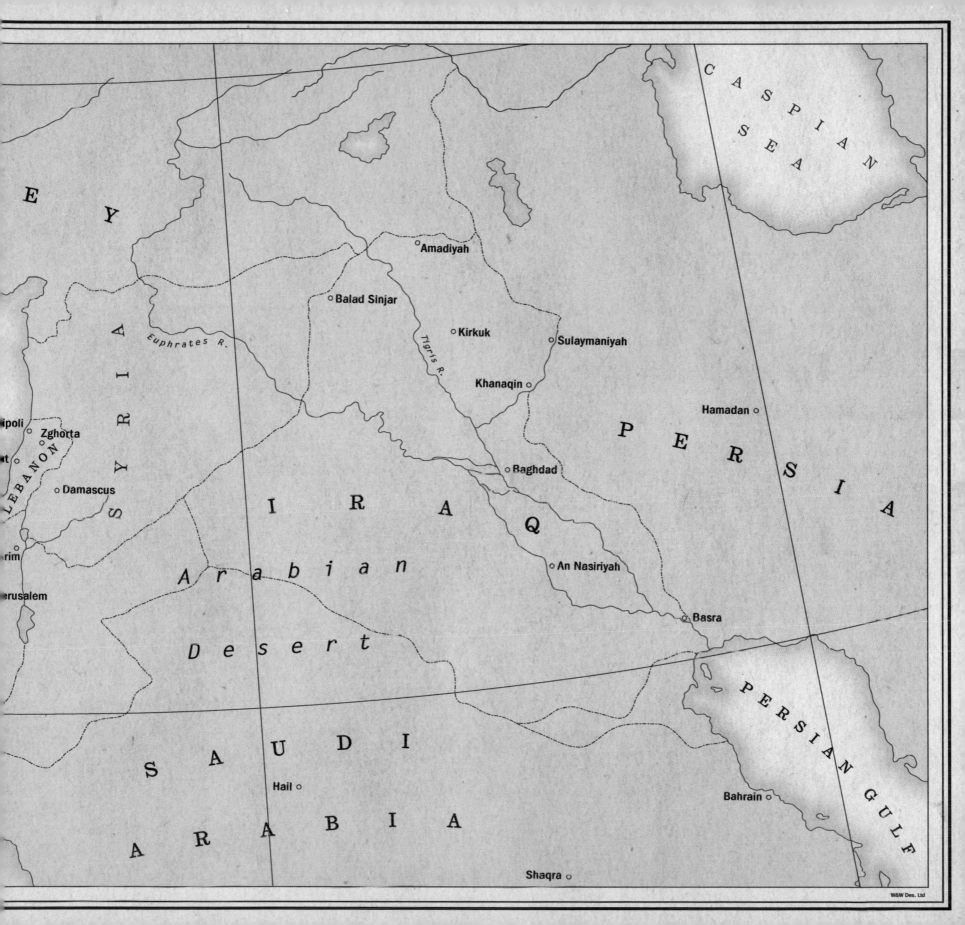

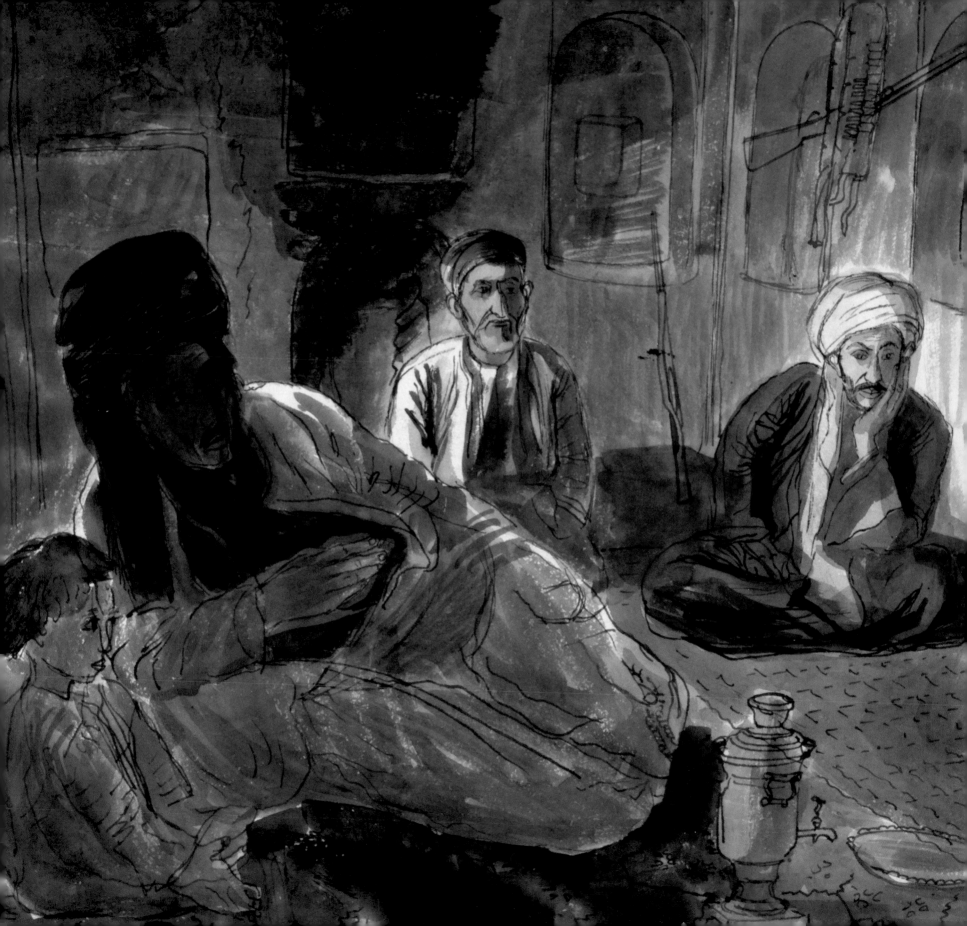

# INTRODUCTION
## NIGEL WEAVER

Artists have been involved in recording wars for many centuries – the Pharaoh's tombs in ancient Egypt and the 11th century Bayeaux Tapestry come to mind – but it was during the First World War that the British government sought to make the position official by formally deploying artists, including such distinctive names as Muirhead Bone, CRW Nevinson, Paul Nash, and William Orpen. Propaganda was a significant objective in this decision.

This tradition of artists recording the conflicts in which Britain is involved continues to this day, although latterly the development of television and video recording has changed the arrangements, with the emphasis now on current reports for nightly news programmes. In more recent years the introduction of 'embedded' journalists, with or without television cameras, has allowed reporters to accompany troops into action. The apogee of this must have been in January 2007 when Sean Langan, of the *Despatches* television programme, succeeded in being 'embedded' in both the British Forces and Taliban sides of the Afghanistan conflict within the same month.

By the Second World War, The Official War Artists (as they were now known) were not yet 'embedded' but, rather, attached by the War Artists Advisory Committee to the Admiralty, the War Office and the Air Ministry; interestingly, although given commissioned officer status, they were not under service discipline. Their works had a definite propaganda aspect, being destined for exhibition in Britain in order to help to raise morale and promote a good image of Britain, at war or in adversity.[1]

The re-creation of the scheme in anticipation of war with Germany was very much due to the influence of Sir Kenneth Clark, Surveyor of the King's Pictures and Director of the National Gallery in London, who in the years leading up to the actual declaration of war was able to successfully push for the establishment of the War Artists Advisory Committee in 1939. He became its first chairman.

Clark had various objectives – primarily "simply to keep artists at work on any pretext, and as far as possible keep them from being killed", but he also shared the view that "we should be able to use the work produced as propaganda". He also had wider concerns about Britain's threatened architectural heritage and was instrumental in getting the Pilgrim Trust to finance the *Recording Britain* project, as well as instigating the creation of the Council for Encouragement of Music and the Arts. Later post-war events, his ennoblement to Lord Clark, and his outstanding success as a television presenter of the series *Civilisation* were to consolidate his reputation.

Clark's War Artists Advisory Committee was initially allowed to appoint five salaried artists, and with a modest yearly budget was also enabled to commission work. Over 800 artists were selected from among those prepared, as part of their war work, to abandon their acknowledged areas of success (so Ben Nicholson and Victor Passmore were not considered). Most were selected to undertake specific commissions, like Vivian Pitchforth, who was profoundly deaf, and asked to do work on air raid precautions in London. The list of names of those deployed now sounds like a roll of honour,

Previous spread:
1. Sheikh Shadid Sahib: Chief of the village of Mahsud (Detail)

Opposite:
2. Rabiah, Karim, Khagiza: wife, son and niece of Sheikh Shadid Sahib

and included Henry Moore, John Piper, Michael Ayrton, Graham Sutherland, Stanley Spencer, Carel Weight, Thomas Hennell, Mervyn Peake, Anthony Gross, Keith Vaughan, Leonard Rosoman, Anthony Eyton, and Richard Eurich, among others.

Edward Bawden was among the first five full-time appointees in 1940. The others were Muirhead Bone (a veteran of the First World War), Edward Ardizzone, Barnett Freedman and Reginald Eves. Eves was 64, and an RA. Bawden, Ardizzone and Freedman were much younger, and known as illustrators, a requirement of the War Office.[2]

This book concentrates on the work of Edward Bawden as one of the original full-time war artists. Its publication, nearly twenty years after Ruari McLean's book *Edward Bawden, War Artist* (Scolar Press, 1989, and now out of print) is prompted by the ongoing topicality of Bawden's main area of work: the Middle East. Since the end of the Second World War, the politics of the Middle East have seldom been out of the news: revolutions, conflicts, countries changing their administrations and even their names, the growing importance of oil in the global marketplace and, in the 21st century, the decision to declare war on Iraq. The complicated nature of this war and its aftermath has proved difficult and has served as a stimulus to re-visit the countries that Bawden found so fascinating. Chapter 3: The Political and Military Background, by Robin O'Neill, sets the political context in which the allied forces and Bawden found themselves during the war and sketches the dramatically changed political scenery since then. The final chapter comprises Bawden's own published descriptions of two episodes during this period.

Bawden's time in the Middle East was in many ways, the 'making of him' as an artist. For five years he was prevented from continuing to work as a printmaker, designer and book illustrator. Instead, he was employed to portray the war, his tools were pencil and watercolours. His subjects were mostly people – the local inhabitants in the main – Sheikhs, troops, an Emperor, and children all found their way in to his pictures; and so it was that Bawden was to develop his ability in portraiture. Where, to his delight, buildings with architectural details were to be found, then they too would became part of a new dimension in his work. In retrospect, this Middle East period was the high point of his work in watercolour; now, with the considerable assistance of the Imperial War Museum, London, the opportunity to reproduce them using current high-quality reproduction technology has been taken to enable them to be brought together for the enjoyment of a wider public.

1 For a longer view of Official War Artists in the 20th century refer to Merion and Susie Harries (1983), *The War Artists*, Michael Joseph in association with the Imperial War Museum.

2 How they fared is described in greater detail by M and S Harries (1983).

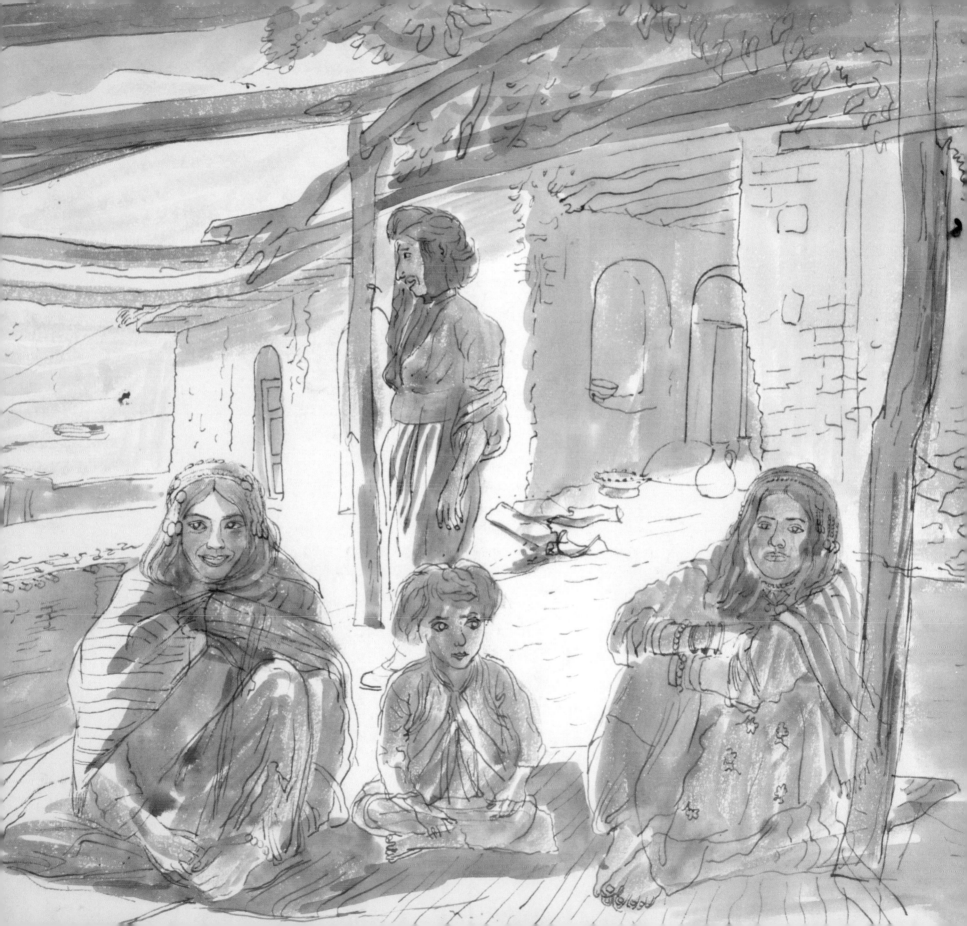

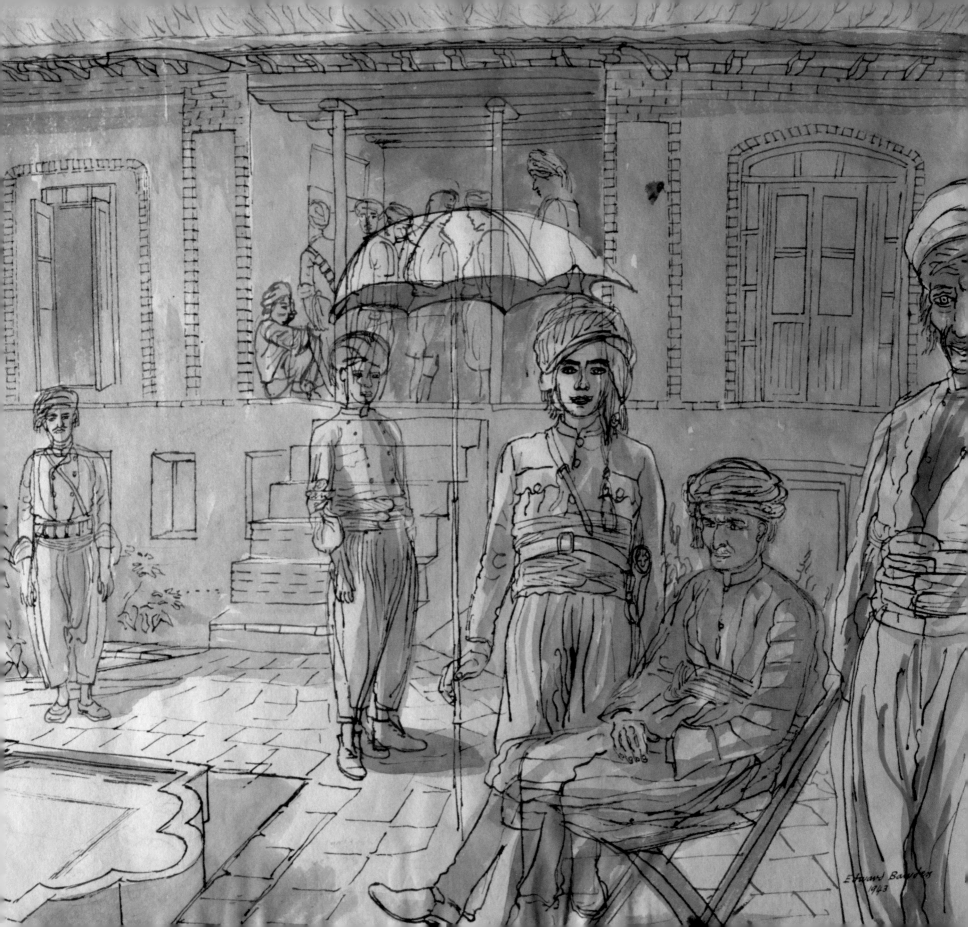

# BAWDEN IN CONTEXT
## NIGEL WEAVER

By the time Edward Bawden died in 1989, at the age of 86, he had seen his reputation soar at an early stage in his career, plateau, soar again, plateau, decline and then finally soar again. He himself was philosophical about this, reflecting to his friends, that 'if you live long enough your time will come round again'. The opening decade of the 21st century has seen his reputation rise still further. As a longer period of time has elapsed for evaluation and appreciation, a new generation has come upon his work, and has been hugely impressed.

Something of a polymath, Bawden's facility in printmaking, watercolour, illustration, mural decoration and design (in the fields of advertising, wallpapers, posters, textiles, book jackets, ceramics, furniture, and shop catalogues), meant that he was never easily classified in the same way as his friend Edward Ardizzone, whose name became synonymous with book illustration.

Bawden's reputation, with its ups and downs, rests upon his achievements all round, though many consider that his major strengths lie in his work as a printmaker and his multi-faceted achievements in design. However, his important contribution to the English tradition of watercolour cannot be overlooked, and is exemplified in his output as a war artist.

Bawden's career, and fortunes, can be seen in the cycle of his life. Born in 1903 in Braintree, Essex, he was already accepting commissions from the Curwen Press and London Transport whilst still a student at the Royal College of Art, London. In the years following his graduation, he exhibited watercolours at St George's Gallery, London (1926 and 1927), before his first major success came in 1928, when he and his friend Eric Ravilious were offered a joint commission to execute the mural in the refectory of Morley Working Men's College in Lambeth. Unveiled in 1930 by the then Prime Minister, Stanley Baldwin, it received widespread praise, and may now be regarded as his first pinnacle of achievement.

In the ten years that followed, leading up to his appointment as a war artist in 1940, Bawden remained on a plateau of success, earning a good living, developing his work in poster design for London Transport, book illustration, in advertisements for Westminster Bank and Shell, wallpaper designs, and in watercolour. It was during this period that he married Charlotte Epton, a potter and painter, with whom he settled in the village of Great Bardfield in Essex.

External events of a different kind were soon to impinge on his life. From 1936 until 1938, there was the period described by Winston Churchill as 'the loaded pause', while the world slowly slithered towards war with Hitler's Germany, interrupted by the false hope of peace following the Munich agreement in 1938 until the declaration of war on 3 September 1939.

Bawden's war career, 1940-45, discussed in greater detail in the next chapter, may be viewed as the second pinnacle of attainment. At the time, the work he was sending back to Britain was the

Opposite:
4. Kurdish Chiefs at an Officers' Mess

Overleaf:
5. Penjwin: View of the Leave Camp

The new century heralded a massive change in attitude towards Bawden's work. In 2003, the Fry Art Gallery mounted a centenary exhibition 'Design: Bawden and Ravilious', the catalogue of which was subsequently expanded and republished by the Antique Collectors' Club in 2005. In the same year, two other books on Bawden were published, both by private presses: Malcolm Yorke's *The Inward Laugh: Edward Bawden and his Circle* (The Fleece Press) dealt comprehensively with Bawden's life and achievements and has since been reissued by the Antique Collectors' Club in a new format as *Edward Bawden and his Circle*; and Jeremy Greenwood's catalogue raisonné, *Edward Bawden: Editioned Prints*, which he edited and produced at the Wood Lea Press, reproduces every print by Bawden between 1927 and 1989. Also published in 2003, *Artists at the Fry* (Fry Art Gallery and the Ruskin Press, edited by Martin Salisbury) contains much information about the gathering of artists at Great Bardfield 1930-1970, as well as essays on the village community, illustrated books and the wallpaper designs by Bawden and John Aldridge.

In 2007, Bawden's work for Fortnum and Mason, which spans many years, was brought together by the Mainstone Press in *Entertaining à La Carte, Edward Bawden and Fortnum & Mason*.

This century has thus opened with a veritable plethora of work about an artist of the previous century, who, in turn, always acknowledged his debt to artists of the preceding century, particularly Richard (Dicky) Doyle.

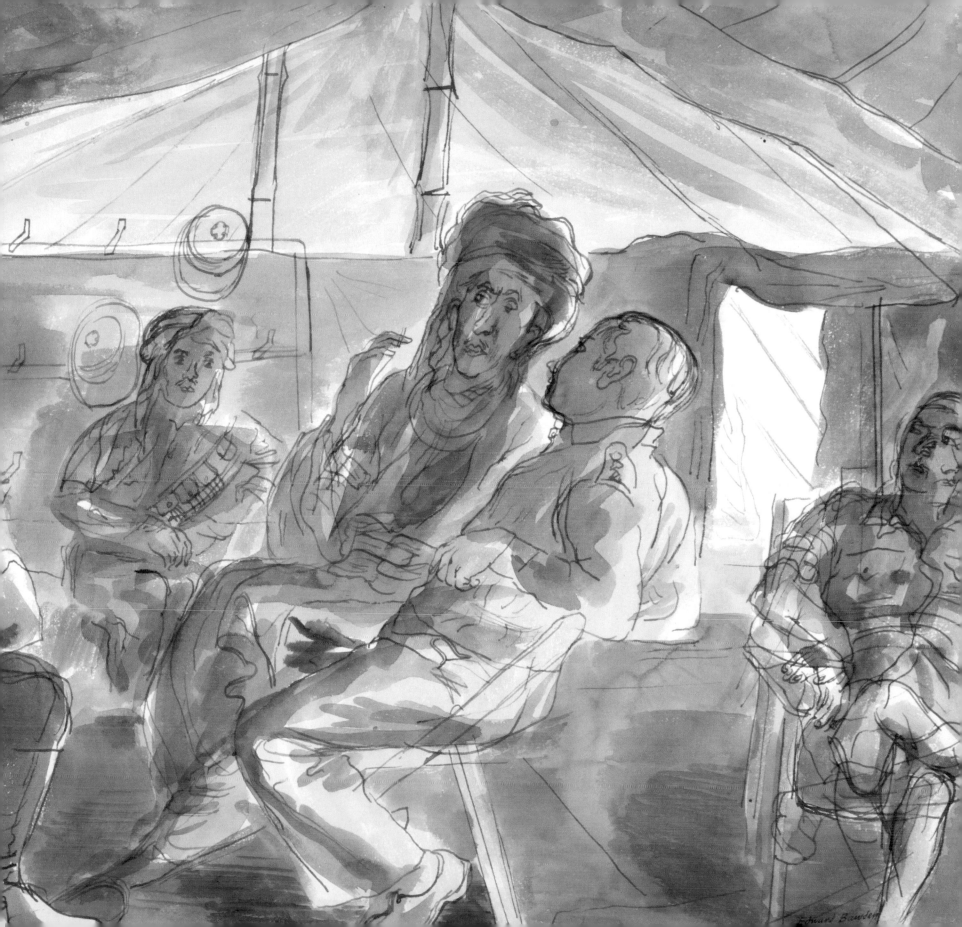

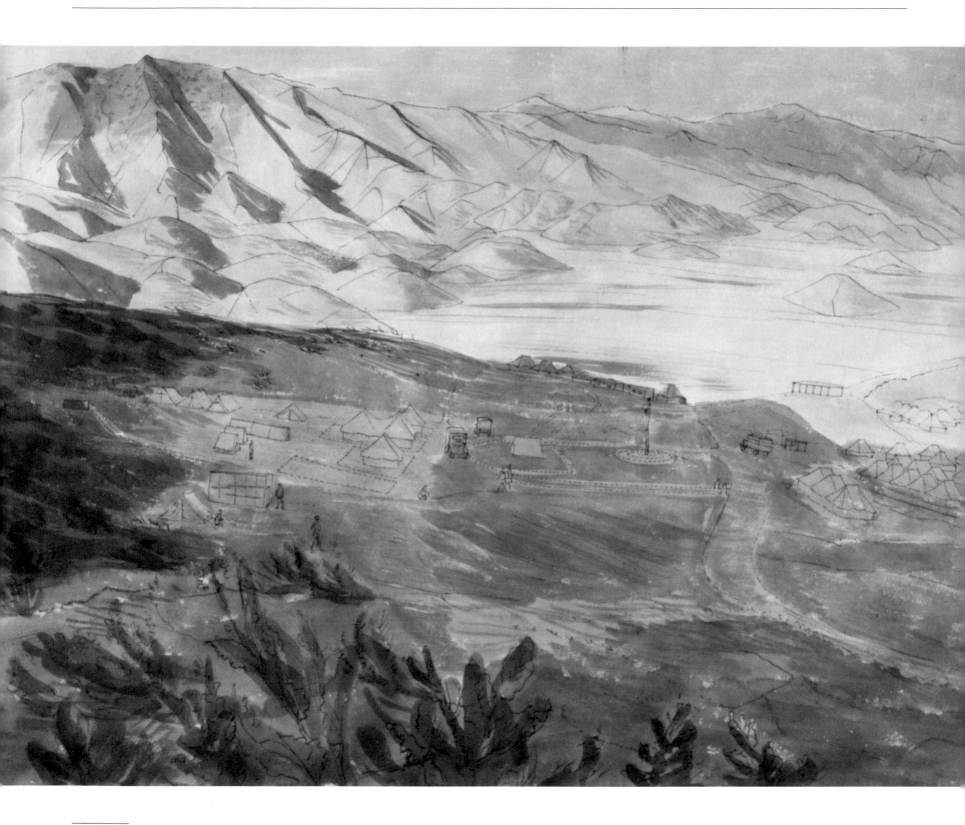

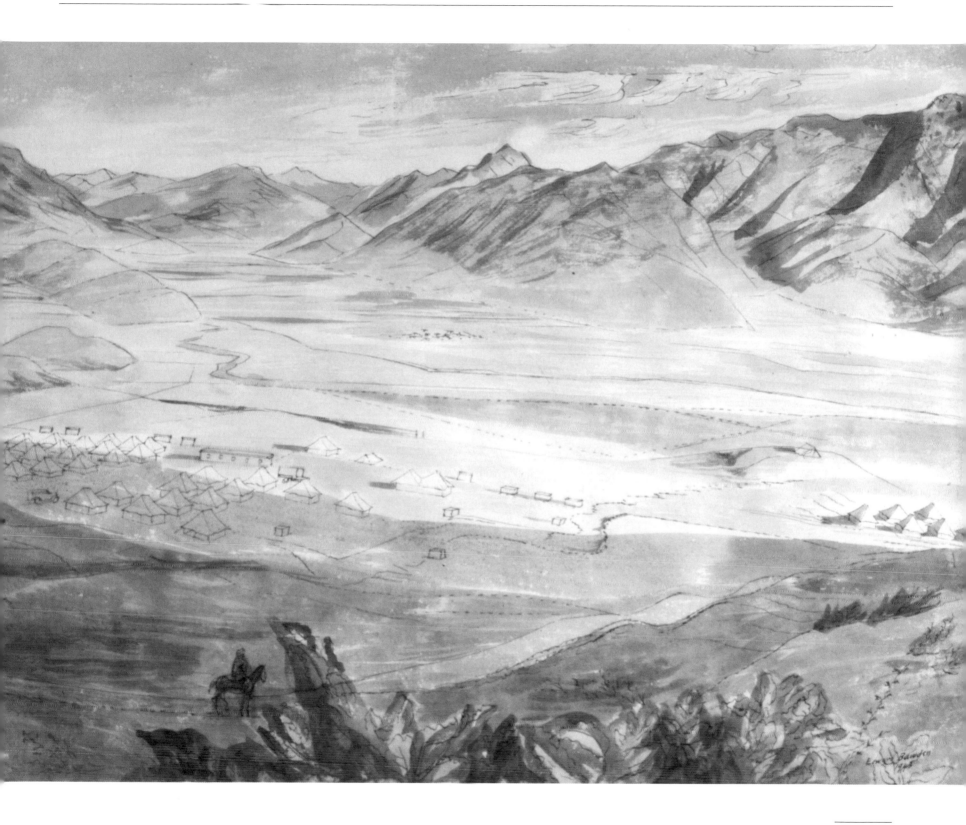

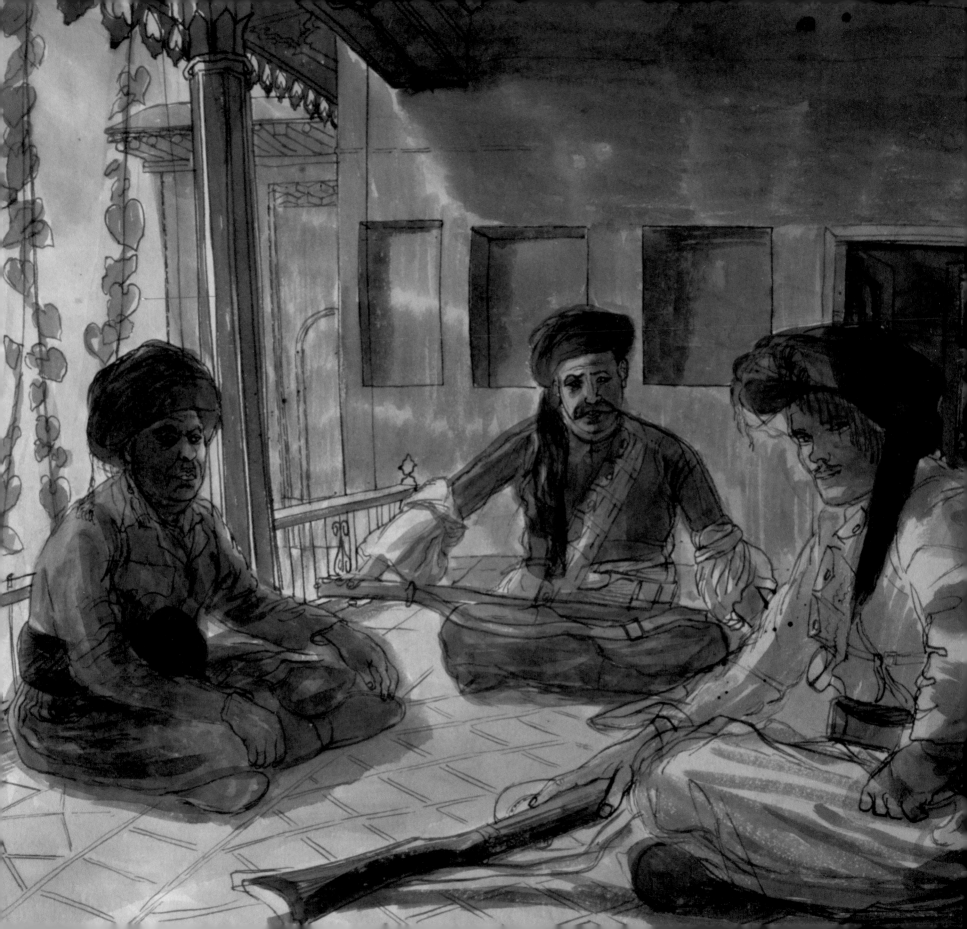

# BAWDEN THE WAR ARTIST
## NIGEL WEAVER

Edward Bawden was 37 years old when he was appointed as one of the first five salaried artists in 1940. He was already an established artist, having graduated from the Royal College of Art in 1925. A few years later he and his friend Eric Ravilious rented half of Brick House in Great Bardfield for weekend use and later, in 1932, when both had married, the two couples occupied the whole house. Though the Raviliouses moved away in 1934, Bawden remained, with his wife and young children – born in 1935 and 1936 – happily living and working in the Essex countryside he so much admired.

By nature an industrious yet shy man, he pursued a successful career in his chosen fields, along with some part-time teaching. His shyness would be a dominant factor throughout his life, but he counterbalanced this with a high degree of self sufficiency, discipline and a strong work ethic.

This strength of character was to be proven during his war-time career. On the face of it, his transition from a structured life in the rural idyll of north-west Essex to the vicissitudes of the war in Europe, the Middle East and surviving shipwreck over the next five-and-a-half years must have been a major upheaval. This is not in any way to say that the trauma he experienced was very different from a great many other civilians, plucked from their homes and daily routines, but rather as a reminder, particularly in view of the extraordinary events that were to befall Bawden in his wartime career, of the ramifications of his appointment.

Bawden had initially been stationed to France in March 1940, only to be caught up in the evacuation of Dunkirk two months later. On 31 May and 1 June, 1940, 132,000 British and French troops were put to rout by the German army, who had broken through the nearby Belgian border; this was a seriously low point in the war, which propaganda was afterwards to term the 'Dunkirk Deliverance'. At the port of Dunkirk itself, confusion existed about how to process an unattached war artist, and Bawden had to secure his own return to England.

By July 1940, Bawden had been commissioned with the rank of Captain, and was posted by the War Artists Advisory Committee to the Middle East. Initially this was in Egypt (Cairo) and from September 1940 to August 1941 he followed the Allied campaign to combat the Italians, who had joined forces with Germany in June 1940. Initially, he was based in Khartoum and Omdurman. From April until June 1941 he was with the 1st Battalion of the Essex Regiment, following the final stages of the Abyssinian campaign that culminated in the defeat of the Italians and the restoration of Emperor Haile Selassie to the Abyssinian throne, from which he had fled to England in 1936. This campaign deserves a 'higher profile' says I.D.F. Jones in his book on Laurens Van Der Post, *Storyteller* (John Murray Publishers, 2001). Jones deals in some detail with the rigours of the campaign, which lasted two months; three groups (one led by Van der Post, but not Bawden's) walked 300 miles at night time. They successfully reinstated the Emperor in his palace at Addis Ababa in May.

Bawden had already met and done a 'fairly good drawing' of Haile Selassie in Khartoum, being 'impressed by the nobility of his features, the dignity of his manner, and the regal gestures which mark him as the greatest personality in the war on this front'. After spending some further time in Eritrea (then still part of Ethiopia), he left in November, to go travelling in the Western Desert, calling at Bengasi, Derna, Tobruk and Bardia in Libya, eventually arriving back in Cairo in February 1942, where he met up with fellow war artist Anthony Gross.

The pleasure of meeting with Gross was evident in Bawden's letter to his wife in July 1942: 'you would not conceive how exciting it is after nearly twenty months to talk openly about painters and painting, or what it has been working without that stimulus.' By this time Bawden's resilience was wearing a little thin, although throughout his correspondence on service he very rarely if ever complained about the conditions in which he found himself. Inactivity was, for him, a major problem. Ever since his Royal College days he had always shown himself to be shy, solitary, industrious to a fault, and disliking any 'hale and hearty' extraverts he came into contact with.

Away from the hospitable homestead created by his wife Charlotte, Bawden seemed impressively able to cope with the physical vicissitudes of life in the desert, in an open boat, or in a prison camp, and with three bouts of malaria, but close relationships with people whose company he did not find very congenial were a greater trial. Perhaps it was because of this attitude that Bawden found the native inhabitants

of each country to his liking. Though he found the tedium of their general pace of life could be trying, particularly so in Arabia, where he complained that 'living alone in an Arab house puts a strain upon the virtues of patience and forbearance'.[1] But he liked Iraq: 'I like the country and I like the people. I like shabby, drab old Baghdad, the mud walls and flimsy balconies, the narrow stinking lanes in the bazaars. I like the men in their sweeping abbas who take life with a leisurely dignity, and the women who get on with it as drawers of water and hewers of wood...'.[2] He particularly related to the native attendants, akin to a 'batman', allotted to attend to his needs. Writing home in 1941, he talked of Abdul, who is 'awfully good and though he does not understand a word of English he understands my wants, and cooked, washed, prepared my bath etc as if trained to do so'. Then came Mohammed in 1942 – able to cook wash and behave in an instinctively sensible and useful manner, and who admired Bawden for being the father of a son – 'the proof of supreme virility' – and who compares favourably with a subsequent (1943) driver/batman who caused Bawden to an explosion of ill temper: 'This London pastry cook sitting on his arse all day, doing bugger all, and complaining of being "browned off", has been a slight drag on my own efforts.'

Bawden was aware that he was not easily part of the usual army officers mess scene. In 1940 he wrote to Richard Seddon, an accredited war artist and former student of his at the RCA, that he found his fellow officers almost insupportable in their narrowness and lack of any conversation. This came across to John Morgan, Welfare Officer with the 6th Indian Division in Bagdad, to whom

such visitors as Bawden were entrusted, when he returned there in 1943. Morgan became a friend of Bawden's and they remained briefly in touch after the war. Morgan kept the letters Bawden wrote to him between 1944 and 1946, and maintained a daily diary. The letters and extracts from his diary have been donated to the Fry Art Gallery by his widow, and this has enabled Morgan's insights to be shared. Being nearer to Bawden's wave length, he noted in his diary that he finds conversation with him "pleasant because I know him and his ways of thought, but other officers in the mess don't get on with him at all. He doesn't open up with strangers and replies almost brusquely, saying that he's quite happy listening to other people talking".[3] In a nice aside, the diarist adds "I should think that a most dispiriting pastime in our mess". Morgan had summed up his new friend in an earlier diary entry when Bawden had spent the day with him, "...we didn't get going very far in talk. He needs warming up or provokation [sic] but once started we can carry on an argument or discourse for days without changing the subject".[4]

The impression that Bawden found the native inhabitants more to his liking than the Brits playing at being British whilst surrounded by sand, locust and stifling heat, becomes apparent from his letters home, which are now in the Imperial War Museum, London. His deft turn of phrase shows Bawden clearly happier in the field than in the officers mess; and so it was with his work.

During June and July 1942, Bawden travelled the swamps of the Euphrates by boat, exploring the land of the Marsh Arabs. He justified this initiative in a letter to the War Artists Advisory Committee, in which he wrote: "no one, as far as I know, [has] attempted to penetrate this wild region with a paintbrush... Native life does interest me a great deal and for choice I would rather be with Africans, Indians or living alone in a reed hut in the steamy malarial heat of Sheikdom than in the improvised, unprofessional discomfort of an English troops' camp."

In September 1942, having been recalled by the War Artists Advisory Committee, Bawden boarded the *SS Laconia* at Cape Town. With 2,732 people on board (including 800 Italian prisoners of war) it was badly overcrowded when on September 12, as it sailed near the Equator, it was torpedoed by a German U-boat. The drama of the boat's sinking, the death toll of over half the number, of the six days spent in an open boat, and their eventual rescue by the *Gloire* – a Vichy French boat – has been fully told in Leone Peilbard's book *U Boats to the Rescue: the Laconia Incident* (Cape, 1963). The *Gloire* returned the survivors a week later to Casablanca, where they remained as internees until the US army released them in early November. After being flown to Virginia, USA and then crossing the Atlantic, Bawden arrived home on 16 January, 1943.

While Bawden was in England during 1943, fresh plans were made for his return to a new location. In June he wrote to his wife from his then base, the Military Hospital in Colchester, "Clark [Sir Kenneth Clark, Chairman of the War Artists Advisory Committee] has replied to say that my trip's ok. I can go wherever I want; he suggests Irak and

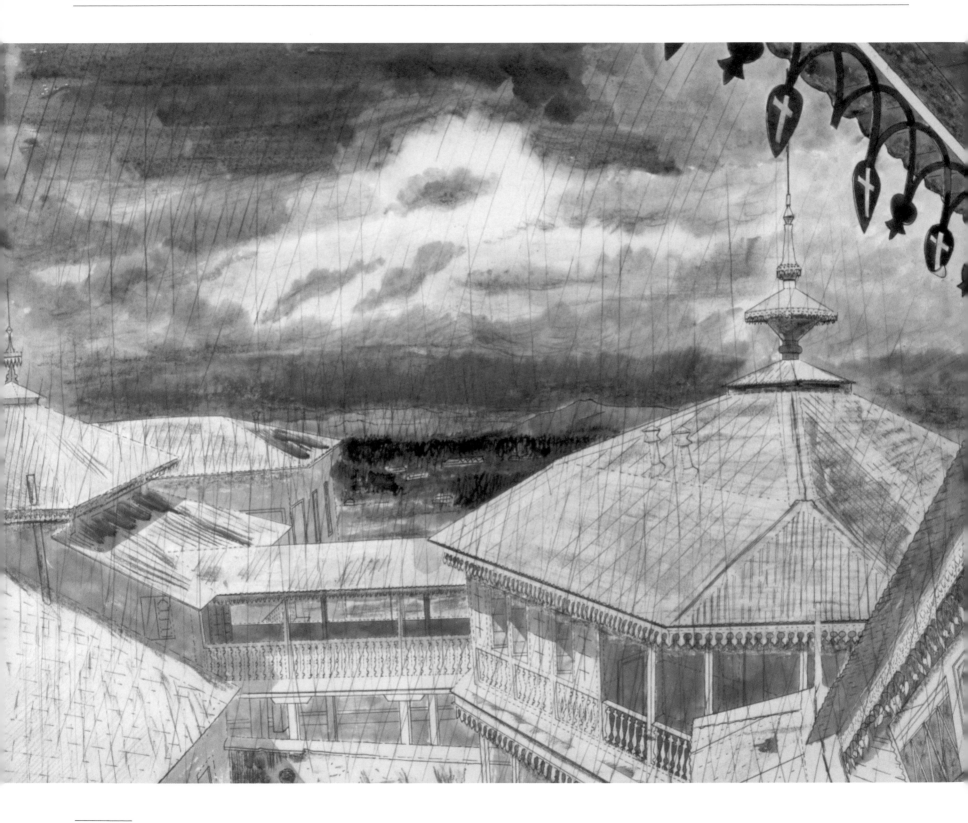

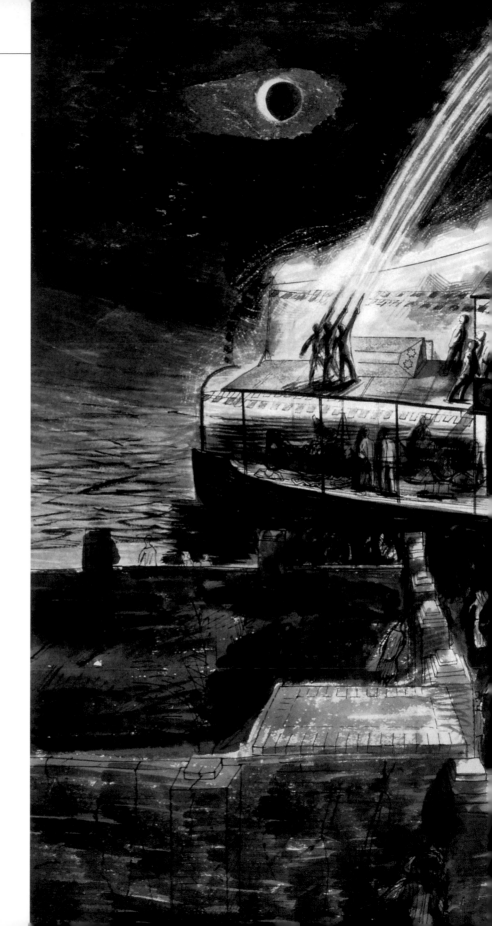

Opposite:
8. The Showboat at Baghdad

Iran. Period: not less than a year. It is tough luck on you, dear, and I wish you could come as far as Cairo so that we could see each other occasionally". On his return to Cairo in September 1943, Bawden was assigned to the Ministry of Information rather than the War Office, and so lost his Captain status. He then travelled to Baghdad and, in February 1944, went to the neutral Saudi Arabia with an anti-locust expedition that was designed to forestall the swarm in their breeding grounds. This interlude was written up by Bawden subsequently in *The Geographical Magazine* (reproduced in Chapter 4). On his return to Baghdad, where he was normally frustrated by the teeming crowds that made him "hesitate to commit a public exhibition of myself", from drawing on a bridge over the Tigris, he was able in May 1944 to paint a memorable watercolour entitled *The Showboat at Baghdad*, now in the Government Art Collection. Bawden described the circumstances in which this arose in a letter to his son Richard, "Not very long ago I stayed for several days on a paddle steamer which was hung with hundreds of coloured flags and electric lights. Every day this paddle steamer or 'showboat' as it was called chugged up the Tigris twenty or thirty miles, and every evening as it was falling dark we stopped at a village and moored and a cinema screen was erected on the bank. Hundreds, sometime thousands of people came. Just before it was time to show the films two friends and I went out; on to the roof – where the big funnel sticks out – and with us we each had a pistol. At a given signal the lights – all the lights on the boat went out – then, raising our pistols and pointing them in the air the middle one of us said – 'Now are you ready – fire!' There was a terrific bang as three rockets shot high

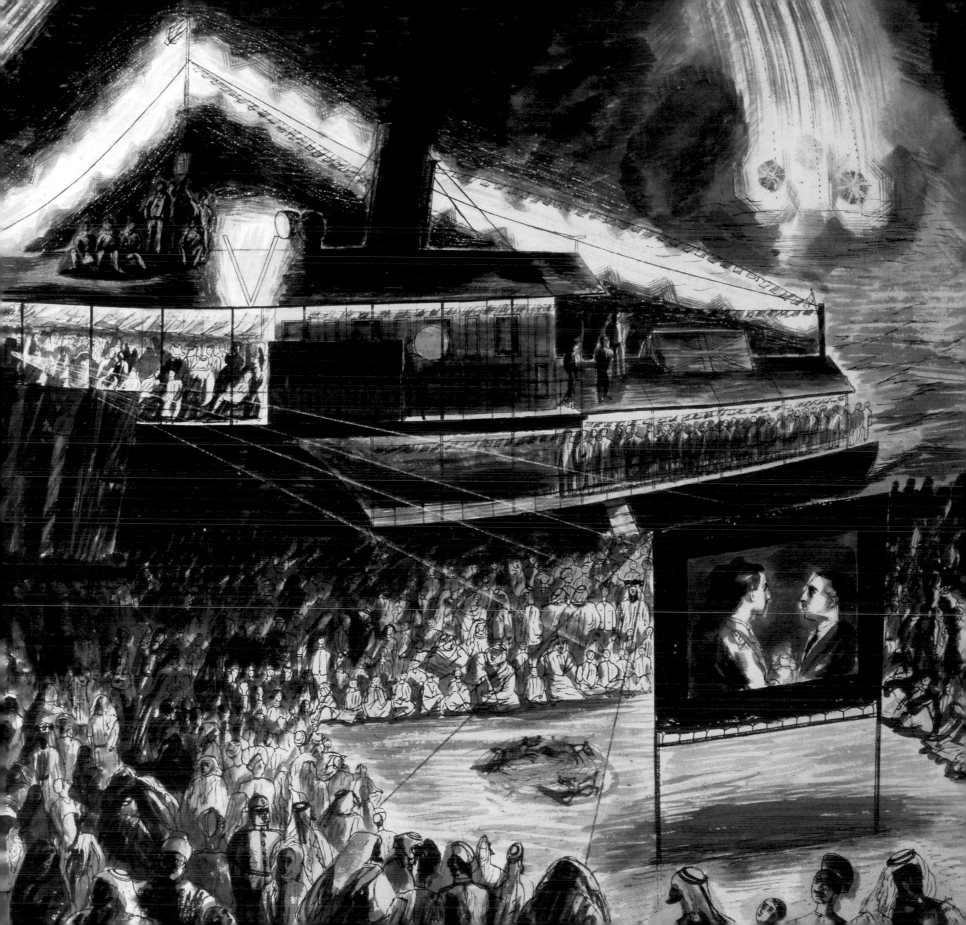

My dear Richard,    Three days ago the King of Iraq, Faisul II had his birthday. He was nine years old. I am told that he likes drawing trains & pictures of aeroplanes, so, evidently he is a very sensible boy. I didn't go into Baghdad to see all the flags, but at bed night I went to bed rather early on the roof & because it was hot & I could not sleep I got up & walked about for a few minutes, then it was that I noticed fireworks, green, red & yellow stars bursting over the Royal Palace. The night was clear & star-lit, a waxing moon hung like a lamp in the sky, & looking over the tops of the dark featherery palms the distant fireworks could be seen shooting into the air like a fountain, many bright coloured stars bursting together & then falling & fading out.    Not very long ago I stayed for several days on a paddle steamer which was hung with

A letter from Edward Bawden, in Baghdad, to his son Richard [Front]

hundreds of coloured flags & electric lights. Every day this paddle-steamer. or Showboat as it was called chugged up the Tigris twenty or thirty miles, & every evening as it was falling dark we stopped at a village & moored, & a cinema screen was erected on the bank. Hundreds, sometimes thousands of people came. Just before it was time to show the films two friends & I went out on to the roof – where the big funnel sticks out – & with us we each had a pistol. At a given signal the lights – all the lights on the boat went out – then, raising our pistols & pointing them into the air the middle one of us said – "Now are you ready – fire!" There was a terrific bang as three rockets shot high into the air, burst into brilliant red, white & green & floated slowly down towards the river in a blaze of light. We fired three rounds before the films began & three more after all the films had been shown. Everyone – especially the boys – burst into cheers.   Well, Goodnight – & love from Daddie

A letter from Edward Bawden, in Baghdad, to his son Richard [Reverse]

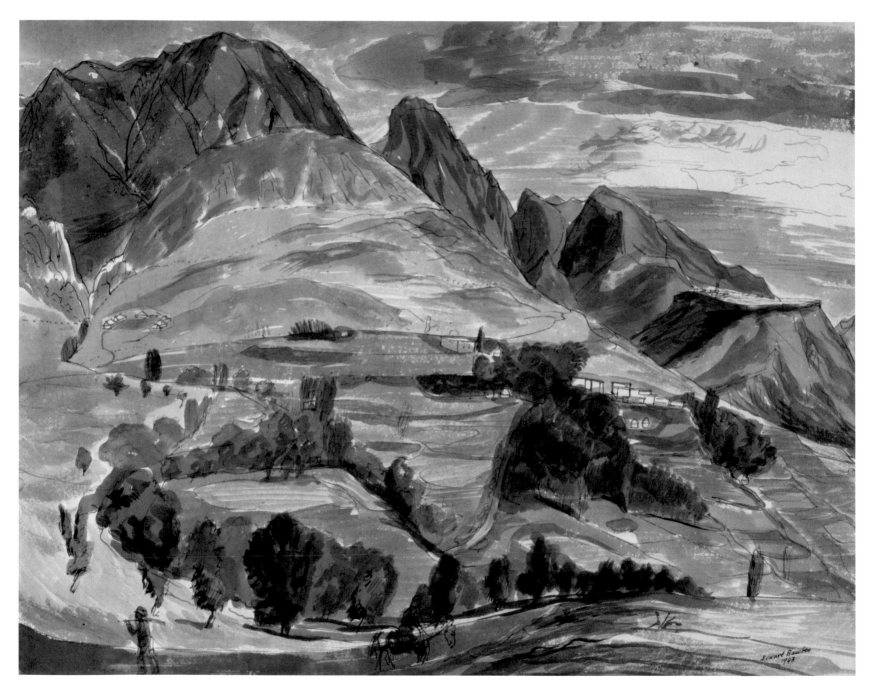

9. Amadia: A view of the town and of the camp of the Assyrian Levies

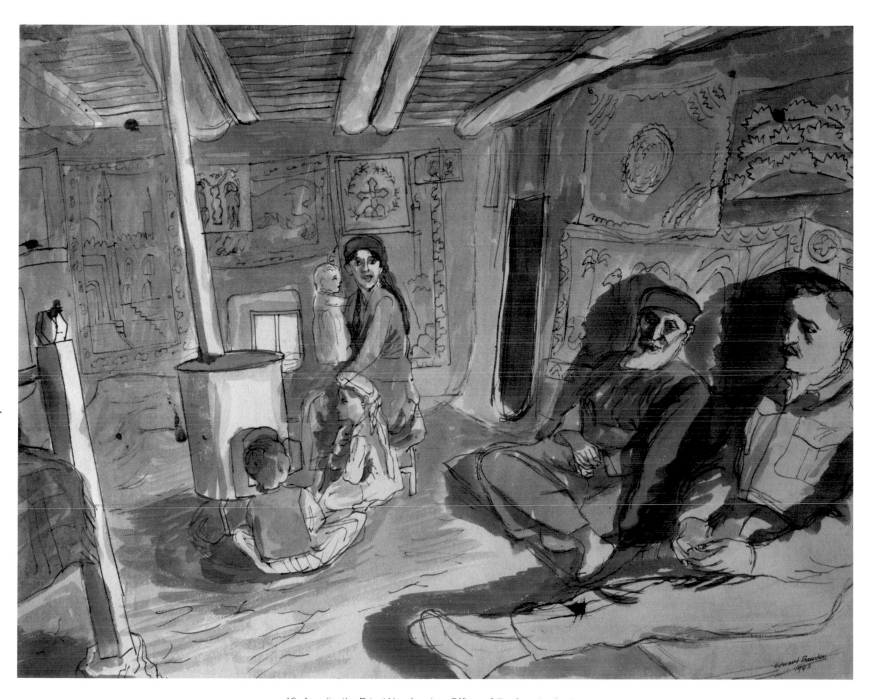

10. Amadia: the Priest Yusef and an Officer of the Assyrian Levies

into the air, burst into brilliant red, white and green and floated slowly down towards the river in a blaze of light. We fired three rounds before the films began and three more after all the films had been shown. Everyone – especially the boys – burst into cheers." The painting shows Bawden and his two friends, not quite so near the funnel as he described, but shooting their rockets, which travel out of the picture and back again over the stern of the boat.

The following month Bawden was invited to spend four weeks in the Munafiq Province, giving him an opportunity to visit the Marsh Arabs, who were, subsequently, to be persecuted by Saddam Hussein. The Marsh Arabs were the subject of a second article in *The Geographical Magazine* (also reproduced in Chapter 4), which reflects a relaxed Bawden enjoying exploration and study among hospitable people who drew "no intolerant line between differences of colour, race or religion, but, as with conversation, tried to ignore the existence of a barrier".

July 1944 saw Bawden in the Pai-y-yak Pass in Persia (now Iran), an important route for badly needed supplies to Russia, which had entered the war on the side of the Allies in July 1941.

Bawden returned to England on the expiry of his year's contract and was there from September until November 1944, before being sent to Italy and Greece, where he was to remain until August 1945. Subsequently, he was awarded the CBE for his services as a war artist. The confidence of the War Artists Advisory Committee in appointing him as an artist illustrator and designer, with a facility for watercolour, had been justified.

Bawden's war career took him across continents, but more particularly it can now be seen, in the words of J.M. Richards, "...[it] gave rise to [his] maturity as a painter",[5] or, as Bawden put it, "I really learned to draw". These five years were seminal, and although much of what he did during that time was to inform his future work, it was never quite the same, particularly in relation to human figures. These, according to his biographer Malcolm Yorke, had previously been, "cartoon homunculi swarming round fantastical architectural settings".[6] During the war years they developed, were seen close up, realistic and sometimes with a feeling that was not to be seen afterwards in his work. In short, it was specifically Bawden's Middle East years that developed his more powerful and imaginative work.

1 War Artists Advisory Committee, May 1944

2 WAAC September 1944

3 6 August, 1944

4 25 July, 1944

5 *Edward Bawden*, The Penguin Modern Painters series, Penguin Books, 1946

6 *Edward Bawden & His Circle*, Antique Collectors' Club, 2007

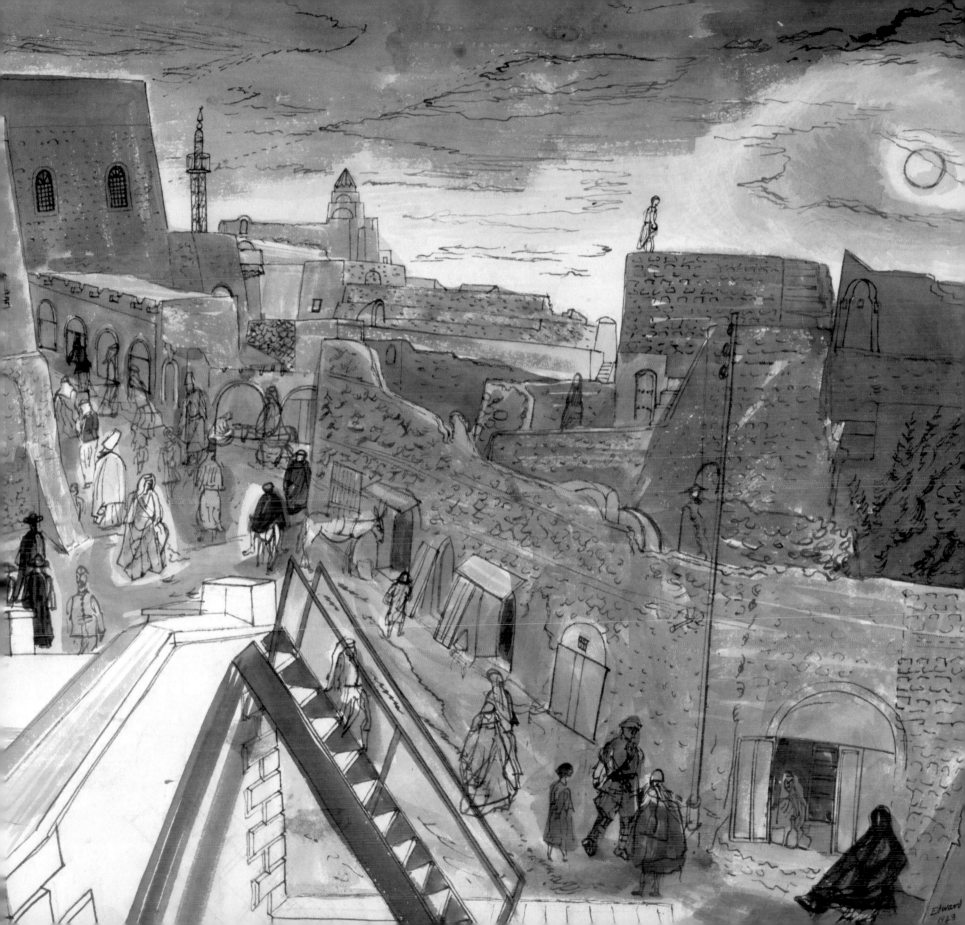

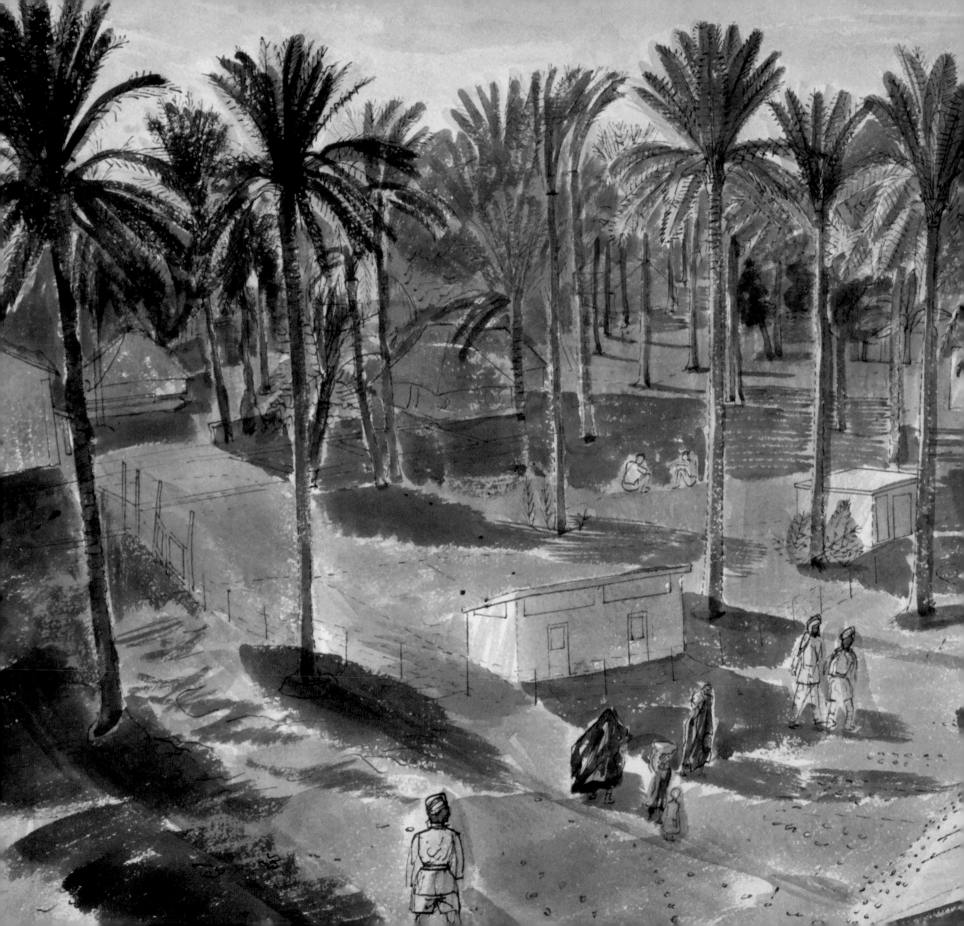

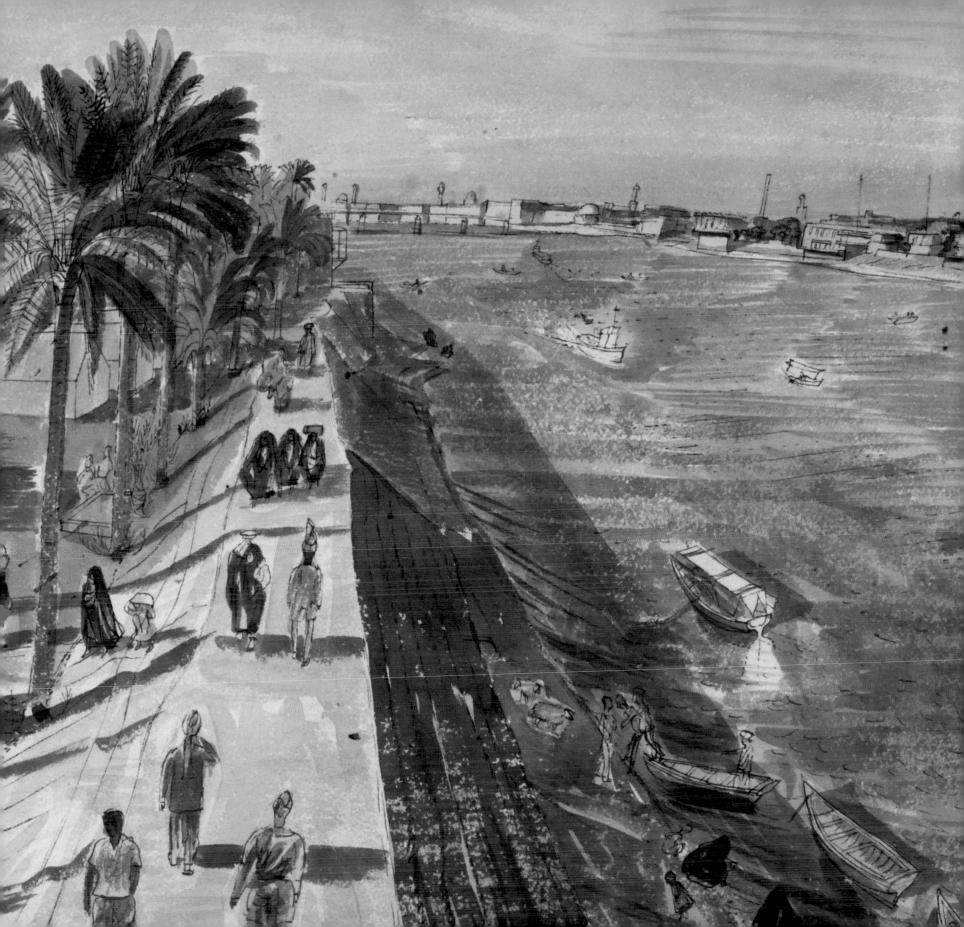

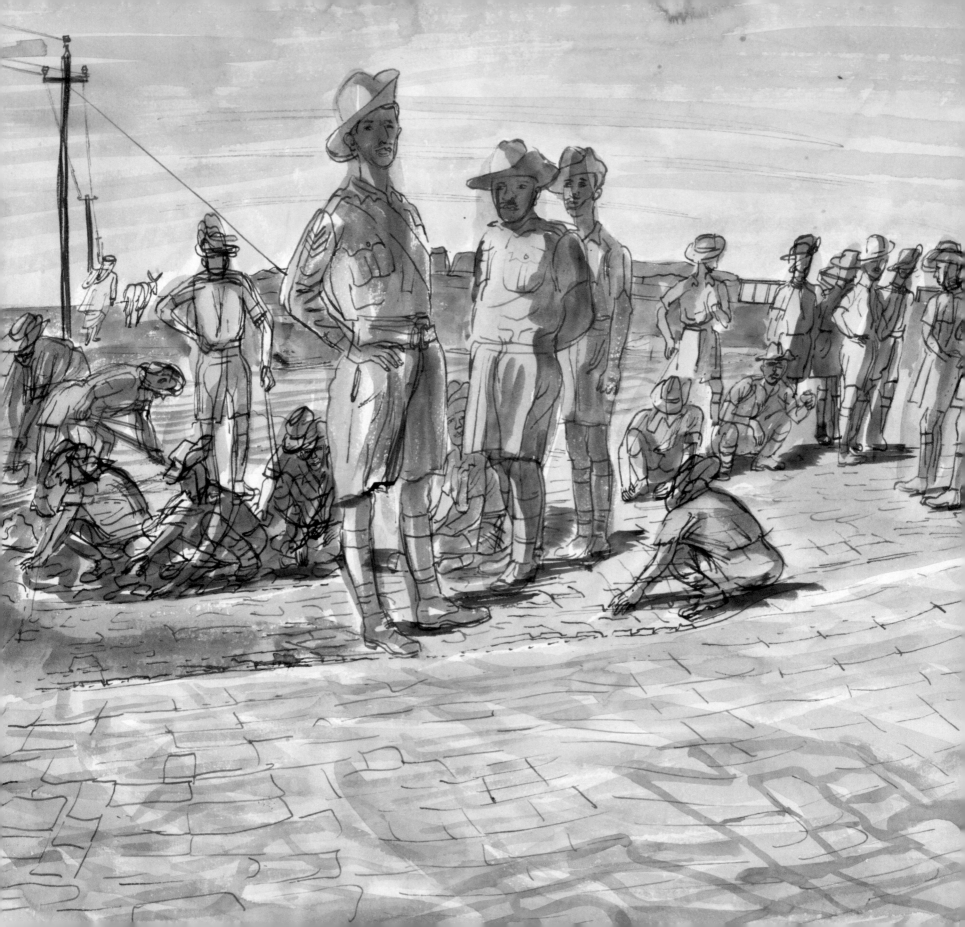

# THE POLITICAL AND MILITARY BACKGROUND ROBIN O'NEILL

Iraq was to prove the quietest theatre of war in which Edward Bawden would serve during his time as an Official War Artist. By the date of his arrival there in 1943, he had already been evacuated from Dunkirk, had seen service in the Abyssinian campaign of 1941, had been torpedoed at sea, interned, and then freed in Morocco. In Iraq, by contrast, he never heard a shot fired.

In 1943, Iraq was, in effect, under British military occupation – as, indeed, it had been in practice for the greater part of its history as an independent state. The British military presence in Iraq had its roots in a Treaty of Alliance and Mutual Support of 1930. Under the treaty each country agreed to come to the assistance of the other in event of attack. The treaty also included the right of passage through Iraq, and gave Britain the right to maintain two military air bases in Iraq at Habbaniya, west of Baghdad, and at Shuaiba, outside Basra. Both were primarily staging posts on the air route to India. This predominant British position reflected the circumstances of Iraq's creation, and much of its short history.

The formation of Iraq as a state, out of the three Turkish vilayets, or provinces, Mosul, Baghdad and Basra, had come about after the First World War following the collapse of the Ottoman Empire. Mesopotamia, as it was then termed, was of great stategic importance to Britain when war was declared on Turkey in 1914. Its oil fields and the pipeline to Abadan were essential for fuelling the ships of the Royal Navy, and it was regarded as of vital importance in safeguarding the threshold to India. Indeed, the whole region was treated as coming under the Government of India, rather than that of London, in foreign policy terms. Indian troops landed at Basra within a few days of the declaration of war on Turkey in November 1914, but the campaign against the Turks subsequently proved difficult.

Arab nationalism and resentment of Turkish rule, were already combining to be a growing political force by 1914. Arab leaders took advantage of the war to rise against their rulers, and in June 1916 Sherif Hussein, the Lord of Mecca, proclaimed Arab independence. The Arab Revolt put the Turkish army under increasing pressure, and by 1917 Britain was supplying the Arabs with arms, and regular Arab regiments were being formed to fight the Turks, recruited from Al-ab deserters from the Turkish army and prisoners of war taken by the British. From 1917 onwards, the Revolt and the British campaign in Iraq steadily cleared the Arabian peninsula of the Turkish army. Baghdad was captured in March 1917.

After the end of the war in 1918, the Emir Feisal, the most important Arab leader during the Revolt, aspired to become King of Syria, an ambition supported by the Syrian people generally. However, a wartime agreement between Britain and France had designated Syria as part of a French zone of influence, and France would not agree to Feisal's wish. Mesopotamia was by this time under British occupation and administration, and the League of Nations granted Britain a mandate to continue to administer the territory. In June 1920, the British Government announced that it would constitute Iraq as an independent state, and the mandate would end once it

could stand on its own feet. In August 1921, following a referendum, Emir Feisal, originally from Hijaz (in what is now Saudi Arabia), was confirmed as King of Iraq. It is worth noting that, even at this time, there was pressure, particularly from the Shia community, for the head of the new state to be an Iraqi, which, of course, Feisal was not; the inclusion of the largely Kurdish province of Mosul in the new state of Iraq was also controversial.

The Treaty of 1930 marked the effective end of the British mandate in Iraq. It was terminated formally and, in October 1932, Iraq entered The League of Nations. The last British troops left Iraq in 1937, though the Royal Air Force remained at Habbaniya and Shuaiba. The heavy hand of British influence over all official aspects of Iraqi life had been lightened from 1932 onwards, but it was still present and anti-British sentiment was particularly marked within the Iraqi armed forces. By 1938, Germany was working to extend its influence in Iraq, notably through arms sales.

The Government of Iraq broke off relations with Germany on 5 September 1939, two days after the outbreak of war between Britain and Germany. However, the military reverses suffered by the Allies in 1940 had their impact in the Middle East, and the prestige of the Axis Powers, Germany and Italy, greatly increased. Political sentiment in Iraq moved towards favouring neutrality, if not active support for the Axis, and this was particularly marked amongst a powerful group of senior Iraqi army officers. By the spring of 1941, there were a small number of German aircraft at

Iraqi air force airfields. At the beginning of April 1941, the Iraqi Prime Minister, Rashid Ali, declared himself Chief of a National Defence Government, supported by the leading army officers; the pro-British Regent, with his nephew, King Feisal II fled the country. King Feisal (the grandson of Feisal I) had become King in 1939, aged three, following the death of his father King Ghazi, in a motor accident. Both Feisal II and his uncle were later murdered on 14 July 1958 at the outbreak of the Iraqi revolution. The British response was to inform Rashid Ali that Britain proposed to avail itself of its right under the 1930 Treaty to move troops through Iraq to Palestine. The first British troops arrived at Basra on 17 April, followed by a full Indian brigade on 30 April.

On the same day, units of the Iraqi army moved to positions dominating and threatening Habbaniya airfield. The RAF replied briskly with attacks from the air on these troops, and also on Iraqi airfields, including Mosul, where a Luftwaffe detachment was based. The Iraqi force pulled back from Habbaniya on 6 May. On 13 May, a hastily assembled British flying column entered Iraq from Transjordan, and advanced towards Habbaniya. On its way through the desert it came under attack from German aircraft operating from airfields in Syria (under control of the Vichy French Government) and from Mosul and Erbil. Habbaniya was relieved, and on 29 May, the British forces moved towards Baghdad. The next day, Rashid Ali fled to Persia, and Baghdad was entered without any fighting. The Regent returned to Iraq, and the Iraqi Government agreed that a British force should occupy Mosul.

This incident ended what had always been a less than serious German threat to Iraq. Rashid Ali must have been encouraged to expect German help when he moved against the British presence, but he signally did not receive any. Germany had played on anti-British sentiment, but did not back this up in time with practical help. In mid May 1941, several train loads of military supplies had reached Mosul from Syria, and both German and Italian aircraft were sent to Mosul. In the course of the short action to relieve Habbaniya almost all of these aircraft were destroyed. At the end of May, Hitler signed an order to give assistance to the 'Arab Liberation Movement' in Iraq, through making supplies and aircraft available, but it was already too late. The British initiative in responding to the threat to Habbaniya at the beginning of May had in fact been decisive in removing the German threat in Iraq. On 22 June 1941, Germany invaded the Soviet Union, and from then onwards was too preoccupied there to have time or resources to spare for the Middle East. Germany gave no help to the Vichy forces resisting the British invasion of Syria in May, and Syria came under Allied control on 14 July.

Meanwhile, the threat of an early German victory against the Soviet Union posed a potential risk to the Allied position in Iraq, and to the vital oil supplies from there and from Persia, as Iran was then known. The base at Basra was expanded and reinforced, and British troops moved to the north of Iraq and then into Persia, with the primary aim of occupying key oilfield areas in Iraq and in Persia. Little resistance was met within Persia, the Shah abdicated, and in September 1941 British and Soviet forces entered Tehran.

By 1943, when Edward Bawden returned for a second time to Iraq, things looked very different. The wider military situation, as seen not least through Iraqi eyes, had changed fundamentally. Iraq had declared war on Germany, Italy, and Japan on 13 January 1943. The battle of El Alamein in October 1942 marked the decisive-change in Allied fortunes in north Africa. The Germans and Italians had then been driven out of Africa; and in July 1943, the Allies landed in Sicily, and then on the Italian mainland. The German army had surrendered at Stalingrad in January 1943, and in the Soviet Union, the Germans were being steadily pushed back. On 8 September 1943, Italy surrendered. There was no longer any question of a German Middle East threat; but the war in the Far East meant that the lines of communication to India and beyond remained of the highest importance.

Edward Bawden's position in Iraq reflected this change. He was now attached to the Ministry of Information, and his address was "British Embassy Public Relations, Baghdad". The Ministry wanted material for immediate use; Bawden was sent to Persia to record the Aid to Russia supply operation, and also to Saudi Arabia to record an anti-locust campaign that crossed the desert from the Red Sea to the Persian Gulf. His portraits of sheikhs and of village life in Kurdistan, in northern Iraq, and amongst the Marsh Arabs in the south (whom he had already visited in 1942, from Cairo) were directed at public relations in a more local sense, the sheikhs were flattered to be painted. Though, perhaps, there was an element of private "jolly" about these visits as well: Bawden did

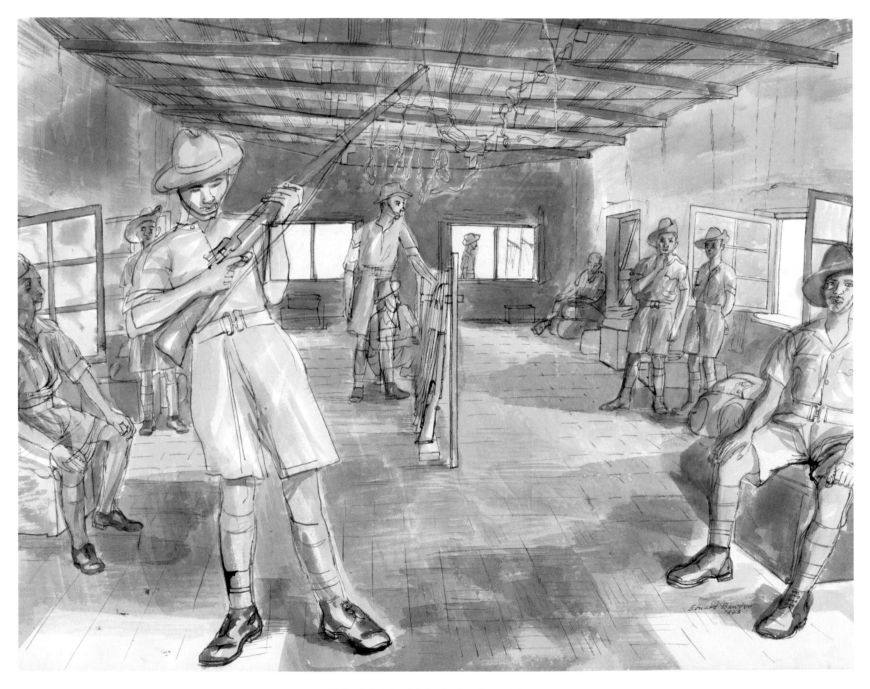

14. Baghdad: Kurdish Levies in a Barrack Room

[n]d only in the Middle East in Iran, parts of Iraq and in [s]maller Gulf states, took on for the first time in many [...] al and then a military character. During the centuries [...] e, the Ottoman Empire, extending from the Balkans [...] ica to the borders of Persia, had not merely permitted [...] rsity, it had insisted on it. Religious communities were [...] ip as they wished, so long as they kept to their place, [...] es and kept the peace: and that meant accepting the [...] fellow subjects.

[...] tion state is very different to a multi-ethnic empire. [...] ose a single national consciousness, but this may not [...] l or cultural diversity. Iraq had been established in [...] lar state, and that was also the proclaimed aim of [...] n. He was a Sunni, but he wanted nothing that would [...] ability of his regime. However, growing religious [...] on a political dimension as well. The grievances of [...] pulation, as well as of the majority Shia community, [...] est marginalised in the Sunni dominated state, led [...] nd unrest. Saddam Hussein's response was a savage [...] pression in the Kurdish areas of Iraq. When he also [...] led in an extended war against Iran in the 1980s, [...] a systematic campaign of suppression of the Shia [...] south-eastern Iraq, including the draining of the [...] the aim of ending their almost autonomous status [...] ir way of life. This gives a particular interest to [...] ngs of both Kurdish and Marsh Arab local sheikhs

and rulers, and the lives of their communities, at a time of stabi[lity] when they were not under threat.

After Saddam Hussein's invasion of Kuwait in 1990, and [...] subsequent defeat, the rest of the world did what it could to prot[ect] both the Kurdish and the southern parts of Iraq from the exces[ses] of his policies, but the tensions within Iraq increased. The fau[lts] inherent from the outset in a state, formed artificially out of differe[nt] ethnic and religious groups, had indeed been identified at the tim[e] but they had been discounted. They finally emerged, starkly, aft[er] the invasion of Iraq by the United States and Great Britain in 200[3], and they are still taking their violent course today.

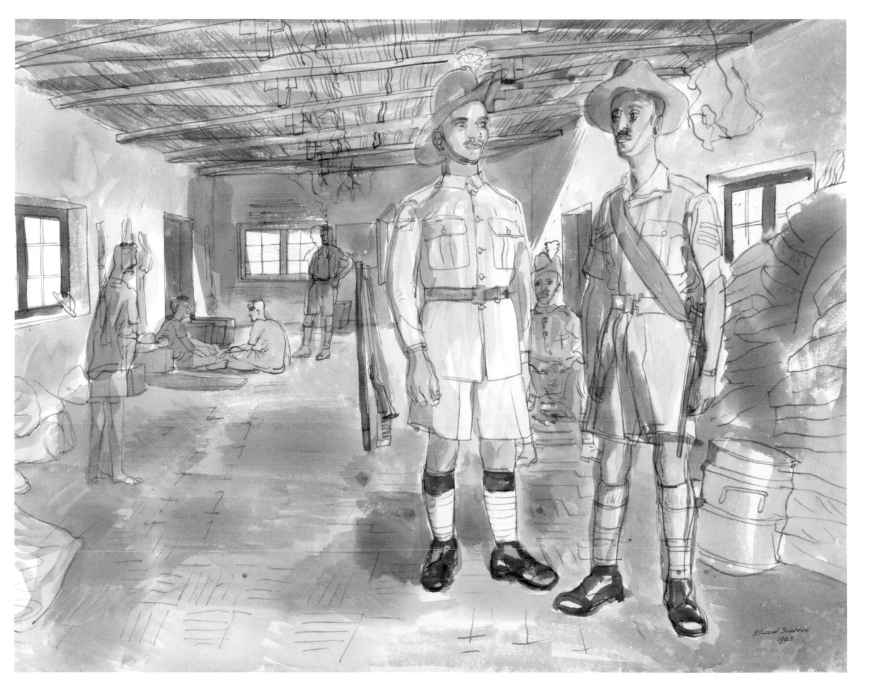

15. Baghdad: Kurdish Levies; on the left a man in ceremonial dress, and by him an Orderly Sergeant

not much like British army life in Baghdad. Bawden's work in Iraq demonstrated characteristic versatility. The watercolours depicting Iraqi policemen and firemen in uniform, for example, recall, in a way, the fashion plates of smart mens' tailoring issued by superior London shops in the pre-war years. Bawden also wrote articles on his Marsh Arab visit and on the anti-locust expedition, and these appeared in the *Geographical Magazine* before the end of the war, in January and May 1945 respectively.

These articles, which were illustrated with reproductions of a number of his watercolours, some of them in colour, carried the impression that an Official War Artist could now deal also with scenes of peace. They describe the marshes and the people of the Muntariq, the province to the north-west of Basra, where the Euphrates opens out into lake and marshland, with an artist's eye. "The exterior of a mahdif (a sheikh's guest-house) might suggest a fanciful tin tabernacle of the Free Churches done in straw by natives of the Congo, but on entering it the impression received by the long, smoke-blackened tunnel was more joyfully reminiscent of an Underground station stripped of the advertisements." And in Jeddah, the starting point for the journey across Saudi Arabia: "At first the setting sun touched the far-away hills, then the tops of the houses, but as the fringes of the golden curtain of light were pulled aside a silvery clearness was left in the air. Now the sky was drained of colour."

Bawden left the Middle East in September 1944, and after a short visit to Britain, proceeded to Rome.

Edward Bawden's paintings depict not only Iraq in wartime, bu an Iraq that no longer exists. Within fifteen years of his departu 1944, the monarchy had been swept away, and the transform of Iraq into a radicalised Arab state was under way. In the after 1945, radical Arab nationalism, which was by no means a movement, grew in strength and confidence. The creation o state of Israel and the 1948 Arab-Israeli war exacerbated its Western strain: the West was held responsible for setting up I The lead given by President Nasser in Egypt, and in parti his successful nationalisation of the Suez Canal in 1956, and subsequent military campaign that appeared to humiliate Br and France, encouraged nationalists in other Arab countries. 14 July 1958, a coup by middle-ranking army officers overth both the government in Baghdad and the monarchy, and the l was murdered. Iraq came under the rule of a succession of mili rulers, the latest and last of them Saddam Hussein.

In the 1960s, the enormous increase in the world price of oil fur strengthened nationalist, and also fundamentalist Muslim sentir throughout the Middle East and, perhaps most significantly, in l Islamic religious leaders proclaimed the doctrine of the Islamic s and in Iran, first of all, this received an important response. But nature of the message from Iran, after the overthrow of the S was firmly that of the Shia strain of Islam. This religious rev paradoxically, had the effect of dividing as well as policiticis Islam in the Middle East. The deep doctrinal differences betw the Sunni, who make up the majority of Middle East Muslims,

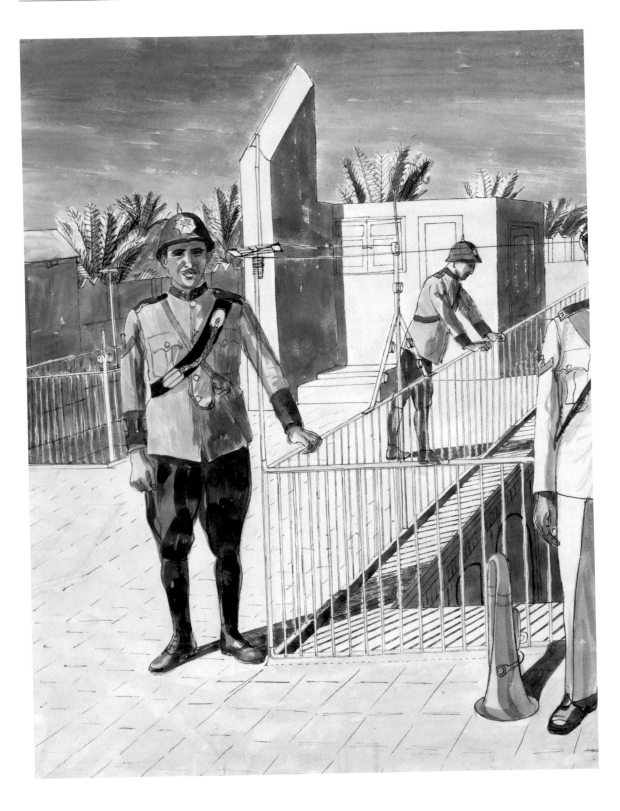

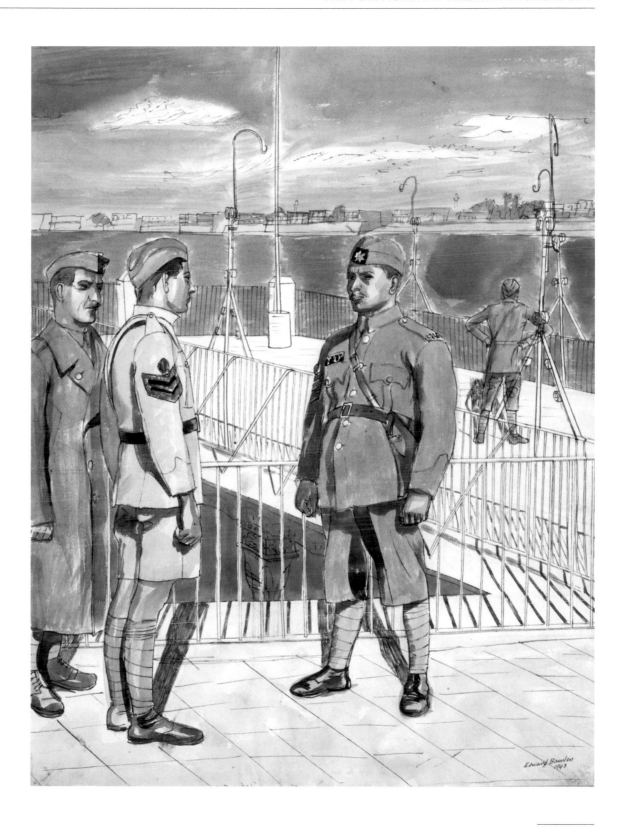

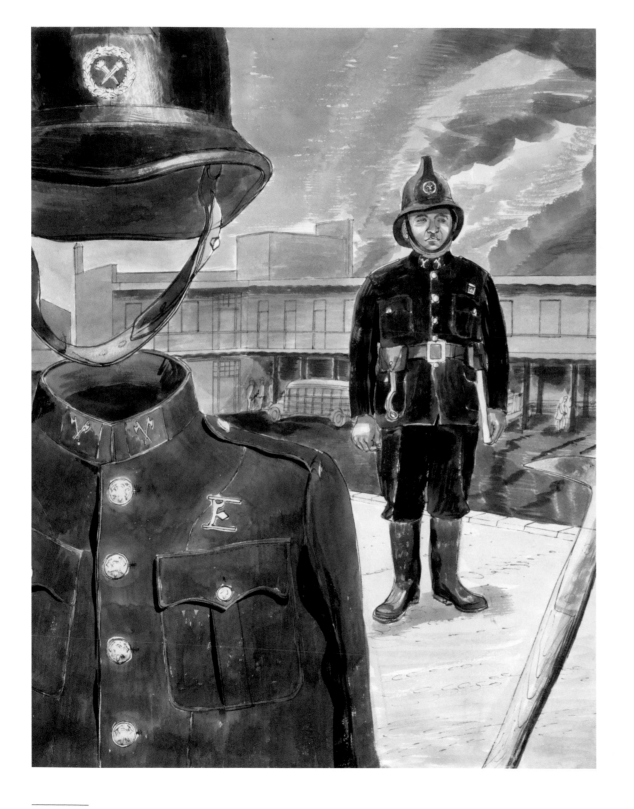

# BAWDEN ON THE MIDI
## NIGEL WEAVER

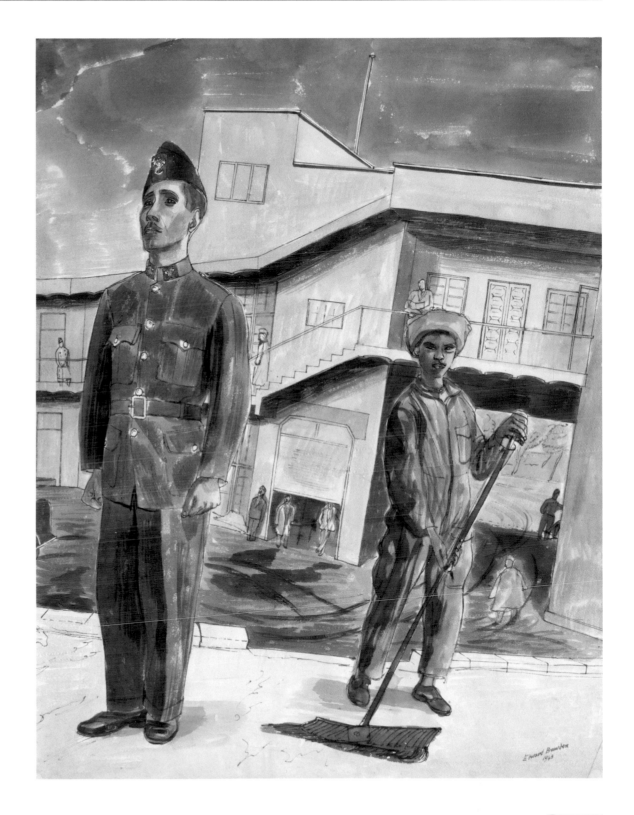

I n September 1944, while Bawden was temporarily in England, he wrote to his wife, "I rather hope that nothing really happens for six weeks – as I told you I saw the Editor of *The Geographical Magazine* and showed her some photographs. She wants two articles, one on Saudi Arabia and the other on the Marsh Arabs, and is willing to pay what Anthony Gross [another war artist] got for his – £20 for 4000 words, or less for fewer words. That is good payment. To write about Saudi Arabia is going to be more difficult than the Marsh Arabs, but I shall try to do the job if I can".

In fact he had met the *Art* Editor, Jean Geddes, who had made a good choice on the magazine's behalf.[1] Bawden, who was widely read, also wrote well and brought the acute eyes of a designer to the task of description. His experience as a landscape painter and his delight in architectural detail had already been demonstrated before the war. To these attributes he also brought a slightly detached view of life, borne out of his shyness; throughout his life he often appeared to be more the observer than the participant in events around him. In the Middle East Bawden appeared happier in the company of the local inhabitants than British soldiers, in one letter comparing the coarse behaviour of the British Tommy in a troop camp to the "Natives [who] without exception have been better mannered". Assisted by their natural hospitality, Bawden soon felt at ease, as

Opposite:
18. A Creek in Sheikh Muzhir al-Gassid's Section of the Hatcham Tribe Territory (Detail)

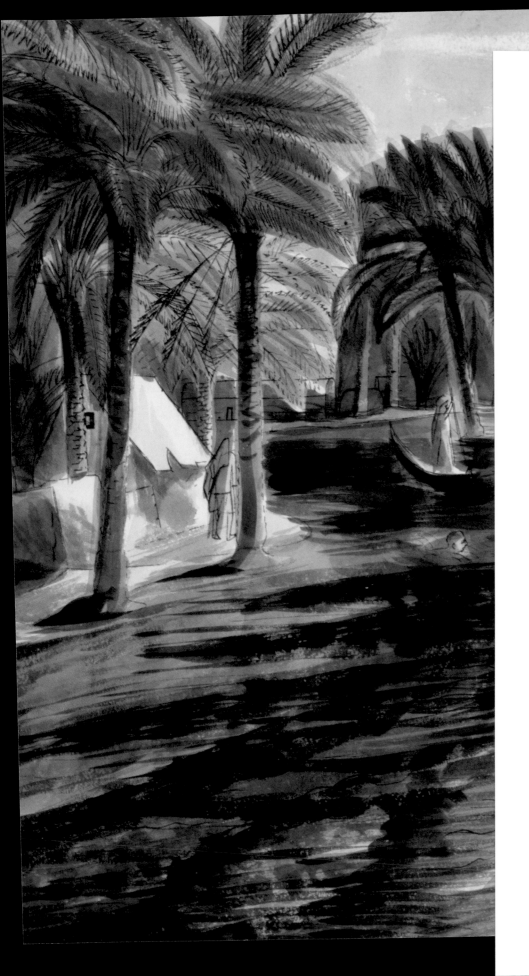

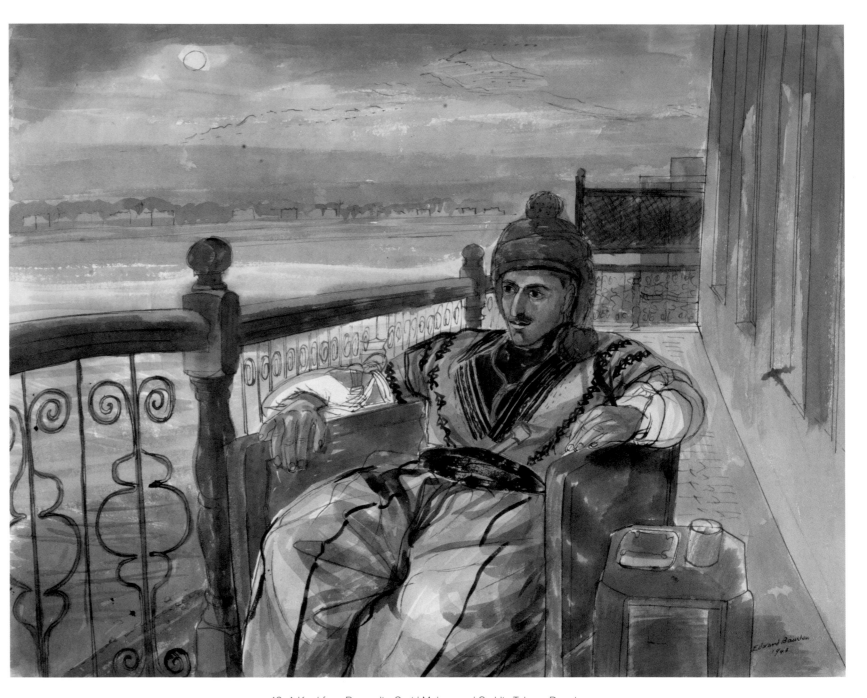

19. A Kurd from Ruwandiz: Sayid Mohammed Saddiq Taha, a Deputy

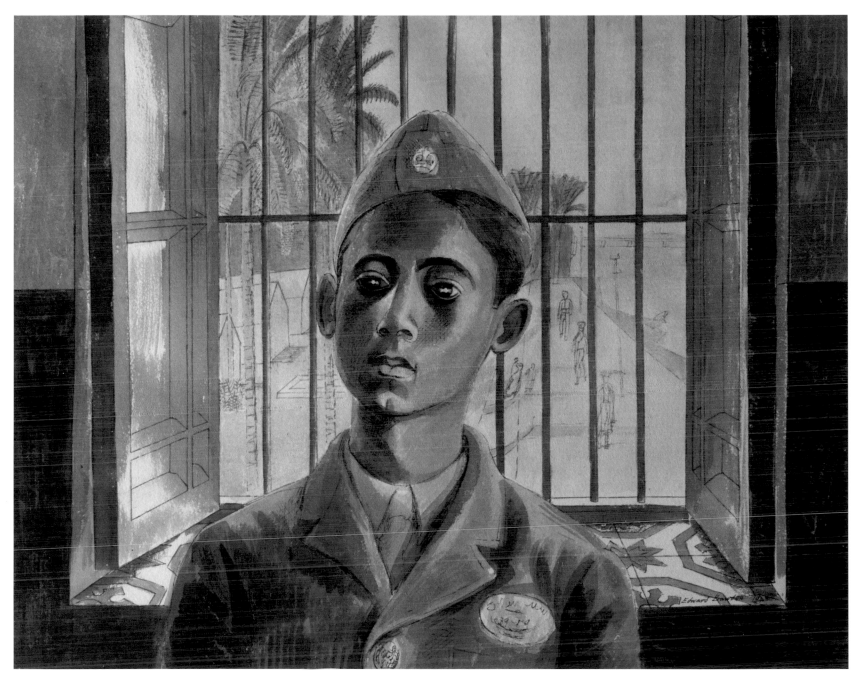

20. Hassan Mirza: son of Mirza Mohammed

21. Sergeant Horne

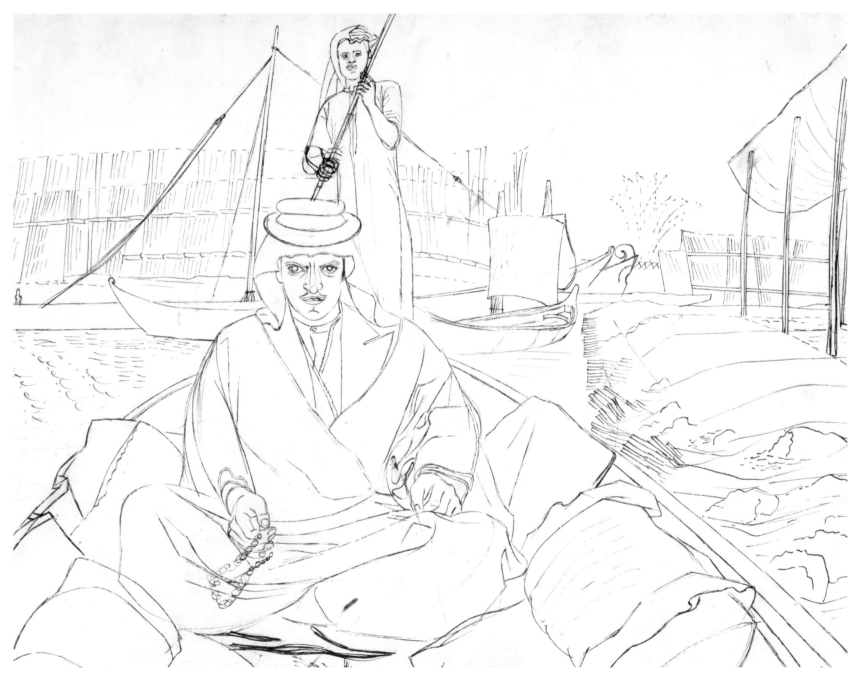

22. Sheikh Sharif al-Hafi

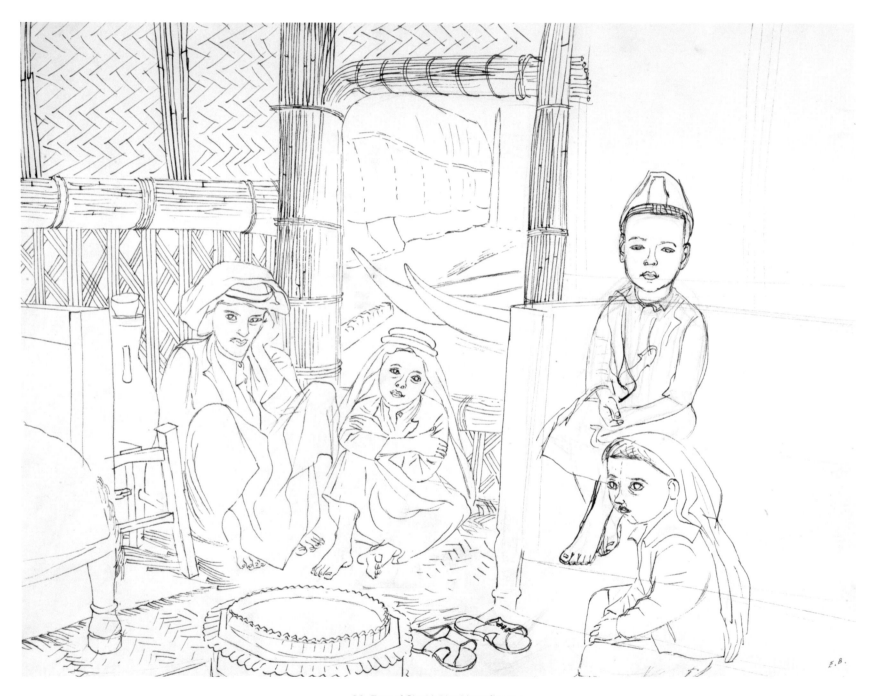

23. Four of Sheikh Haji Maqtuf's sons

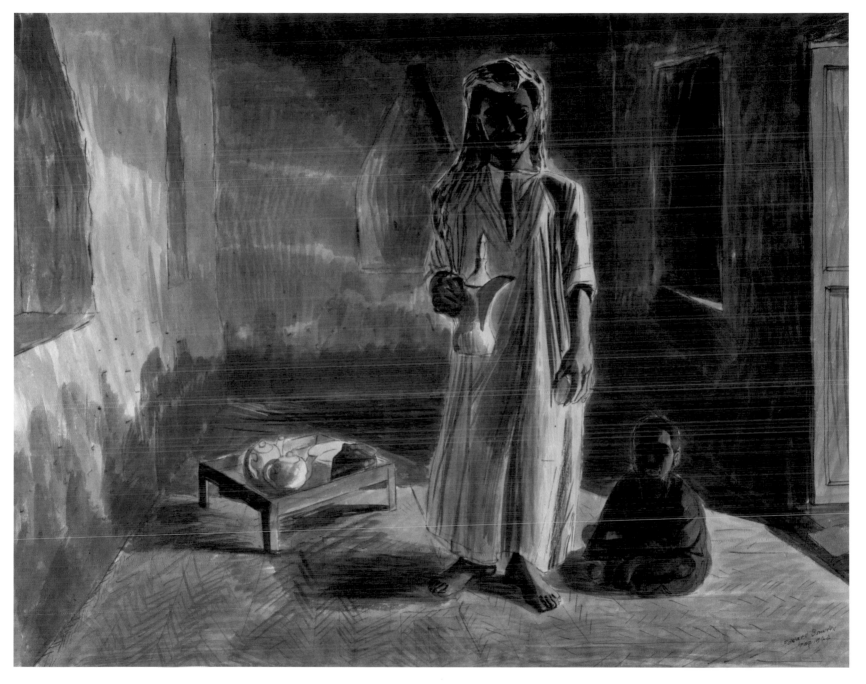

24. A Coffee-man in the Settled Tribe Area

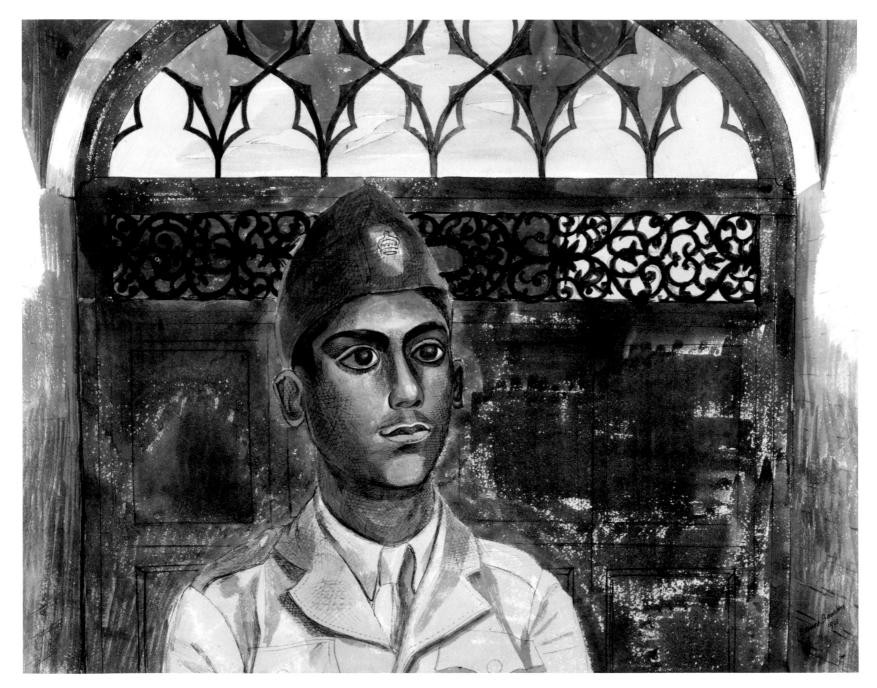

25. Ahwad Abdullah, son of Abdulla the Coffee-man

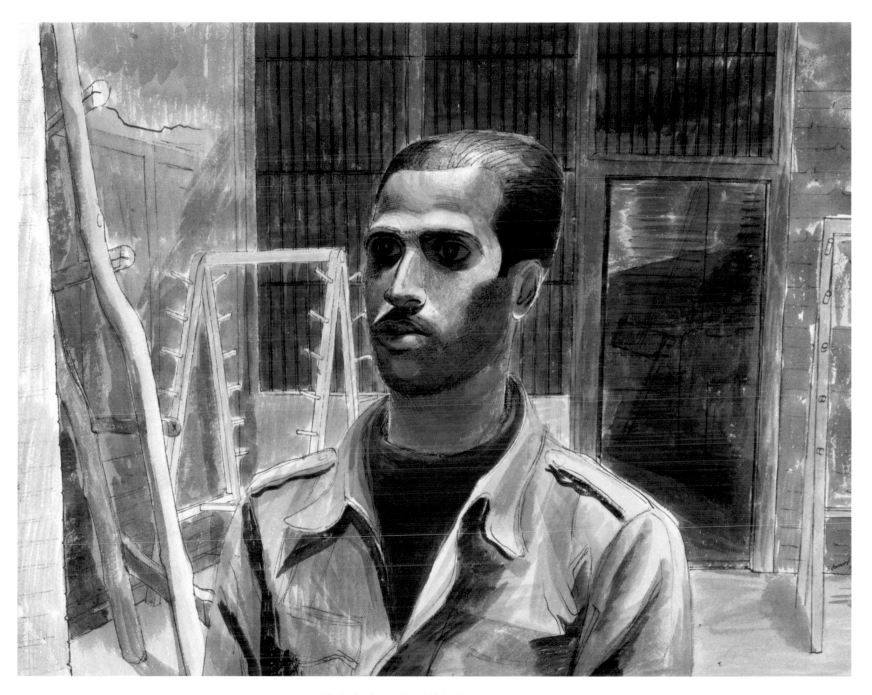

26. An Iraqi Jew: Yusef Haim Shamell, a carpenter

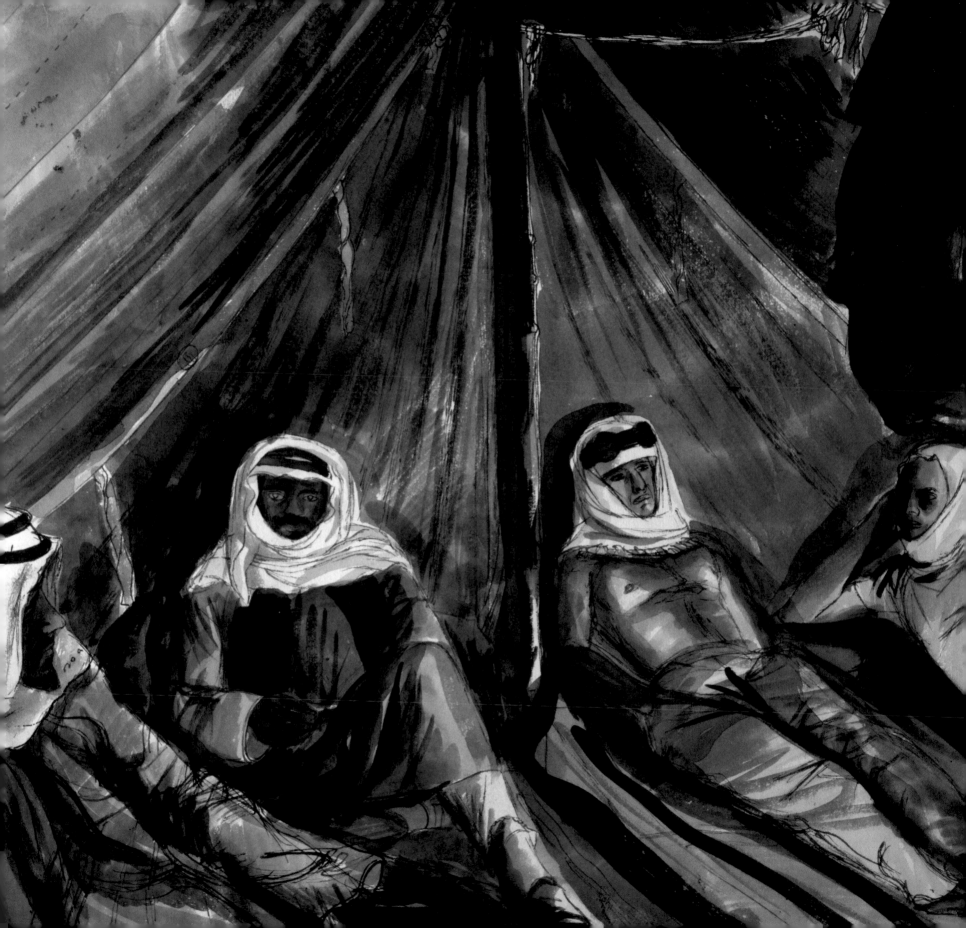

# THE MARSH ARABS OF IRAQ
## GEOGRAPHICAL MAGAZINE
## EDWARD BAWDEN

*Mr Edward Bawden has recently returned from a visit he made as official war artist for the Ministry of Information to Iraq and Arabia. This is his account of some of his experiences while staying as a guest with different Arab sheikhs.* The Geographical Magazine, *January 1945 Vol. XVII No.9*

It was cold standing on the sand by the Baghdad-Basra night train at four o'clock in the morning. In the bleak darkness I stood close to the warmth and dim lights of the train from which I had descended: no one else got off. It was cold and dark, and at first it seemed to be very silent until I caught the faint murmur of people talking: leaving Mohammed with the luggage, I walked round to the other side. I could not distinguish much though aware of the presence of a crowd, but as I picked my steps to a chink of light flashing from a room as the door swung to and fro I found that the ground was littered with untidy bundles lying about in awkward profusion – men wrapped head and heels in '*abas* either asleep or showing a comfortless indifference to their surroundings, and women squatting motionless in groups, heads bowed as though in prayer, their faces entirely swathed in black veils. As the darkness lessened a thin, grey light threaded nearby objects together, then more rapidly it increased until in the starchy white light of the hour before daybreak the scene at Ur Junction became coherent – the standing train for Basra, the small brick-built station office, the crowd seated on the ground. Men pulled aside their '*abas* and put them on, women loosened their veils and the low murmur rose to a vehement clack of conversation. There were stirrings on the train as windows were dropped and heads thrust out to see what were

the chances of getting a cup of tea. A whistle was blown. The train moved slowly, then gathered speed, and I watched it until it became a stationary speck in the far distance.

Without the long line of coaches Ur Junction lost what gave scale and significance to the station. The scene opened to a wide wheel of sand, the level rim of which was broken by the tents of a distant camp and, in another direction, by a few low hills which I did not recognize as the rubbish-heaps on the site of ancient Ur. Among the crowd excitement was being focused upon a coach already crammed crate-tight, but with people still pushing and shoving to get in, all of them, both inside and out, simmering volubly. From somewhere an engine dragged an empty coach which was shunted and linked to the one filled with people; then, feeling self-conscious because of the importance afforded by the contrast, I climbed in with my Sudanese man, Mohammed. A gentle tug was given to the coach and off went the diminutive two-section train on the fourteen mile run to Nasiriya.

Twice in two years I have accepted an invitation to visit Nasiriya given me by Major C. S. J. Berkeley, the British Political Adviser in the Muntafiq. Nasiriya, a small town built by the Turks on the lower Euphrates, is the administrative centre of Muntafiq; and the Muntafiq, under the control of a *Mutas-arrif*, or Governor, H. E. Musa Kadhim, is one of the fourteen *Liwas,* or Provinces, into which Iraq is divided for Government administration. From the point of view of tribal life it is one of the most interesting Liwas. There are

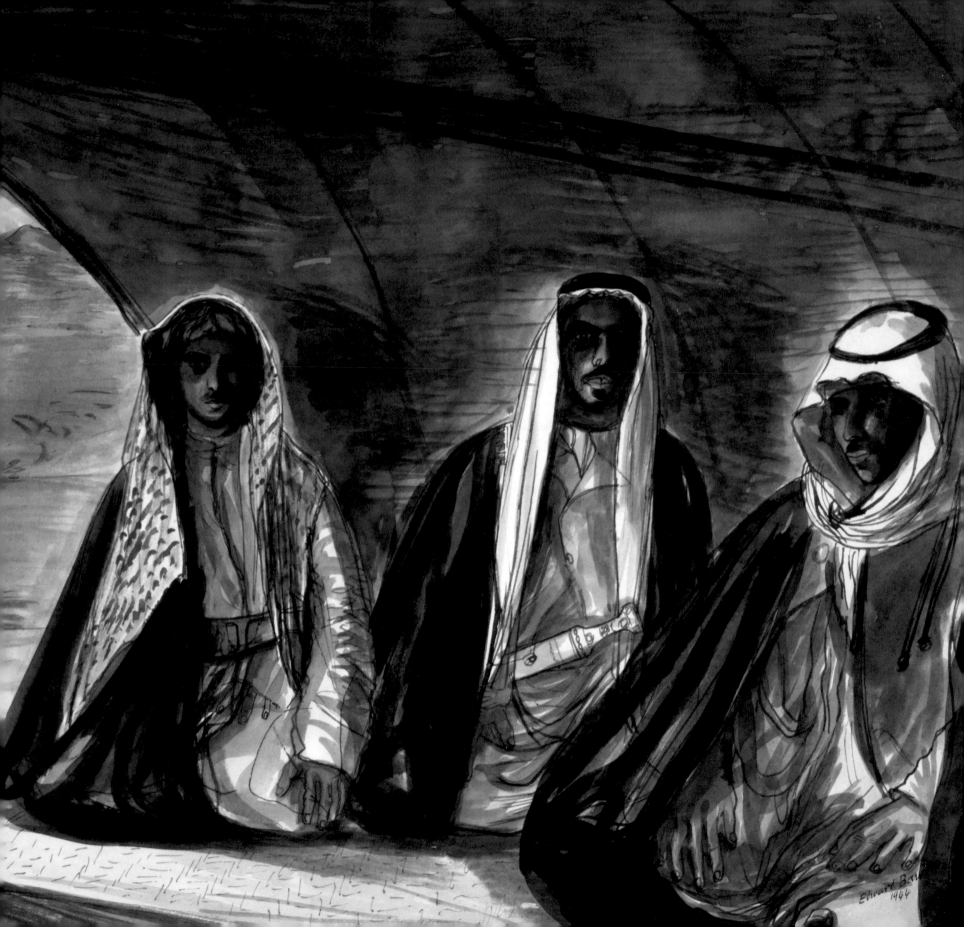

three separate and well-defined types of tribal life: the riverine or Marsh Arabs, locally called *Ma'adan*, living along the course of the river and among the swamps by Hammar lake; the settled Arabs, cultivating crops of wheat and barley on irrigated land; and the Beduin or nomadic Arabs, driving herds of donkeys and camels in search of grazing, who may wander into Saudi Arabia during the winter and spring months. Major Berkeley arranged an itinerary for me so that I should be able to stay as a guest with different sheikhs by turn, and he decided that I should go first to those Arabs living in the marshes.

The trip into the marsh country began at Suk esh Shuyukh. The market town of the sheikhs lies about fifteen miles from Nasiriya; it is lower down the river and in that direction as far as a car can be taken. The first short stretch down the river was made by motor launch. Sheikh Haji Farhud Al-Fandi and a party of Arab friends who were coming for the evening meal met me at the serai. It was hot crushed together in the small cabin, but as the launch swung into mid-stream a light breath of air due to the motion of the boat touched my hot, sensitive skin as softly as a feather. In a few minutes the launch was chugging round a wide bend, and a lovely vista opened of broad, muddy water swirling with the current and banks fringed with dense plantations of palms. At the entrance of a creek we were transferred from the launch into several small gondola-shaped boats waiting for us by the bank. With two men poling vigorously, one on the prow and another standing on the stern, and the strong current in our favour, the boat, called a *mash-huf*,

slid down the creek with an easy, rocking movement as though sliding upon ice. A jungly growth of palms, seemingly as endless as a forest, filled the plantations on each side; the foliage of those trees nearest to the creek arched overhead. Seen from water level, the palms appeared enormous in size. Nothing stirred the heavy fern-like fronds that stretched out. Underneath, among a multitude of trunks, dark strips of shadow wove a deceptive darkness. With the darkness was silence; it was breathlessly quiet, deserted, a shadowy interlacement of palm boles and stiff, sword-like leaves. But was it so quiet, or deserted, only filled by tigerish lines of shadow falling across the ground and the trees? As the senses responded more sensitively, the eye, becoming observant, picked out the shadow-hidden activity, the solitary reed hut draped by the large leaves of a climbing cucumber, or a man or woman motionless, watching, or at work; so too the ear became attentive – a jay might be heard shrieking among the trees as though a squeaky door had been opened and shut very rapidly several times, and the low, warm purring note of the pigeon near at hand. In the current a swimming terrapin or a turtle might raise its head like a periscope and at once clap it under water again. The blue flash of a kingfisher cut the air. A speckled bird hovering four feet above the surface dropped like a stone and emerged with a silver fish. Sitting comfortably cross-legged on the carpet at the bottom of the boat, supported behind and wedged in with cushions, I smoked a cigarette and felt at ease.

The boats drew up to the sheikh's *madhif*, or guest-house, but we were taken instead to the *diwaniah*. This was a mud-and-timber

pavilion on one side, but partitioned to produce the effect of an outer and inner sitting-room, the former set out with long, wide wooden pews covered with carpets, the latter furnished with low easy-chairs, spindly occasional tables for holding ash-trays and at one end a large piece of furniture with pegs and a looking-glass. A number of Iraqi flags had been sewn together to serve as a banner decoration for the full length of the back wall: pinned high up over the hall-stand was a poster with a portrait of Churchill. In the diwaniah the initial ceremony of taking coffee was enjoyed more informally than would have been possible in the madhif. On other days I used it whenever I needed the relaxation of semi-privacy, or a sleep during the hot hours when most things are quietened by the oppressive heat, except for the flies which were quickened to feverish activity and the fleas that were slyly troublesome at inopportune moments.

With sheikhs who did not possess a diwaniah I lived in the madhif. A madhif can be spotted a great way off because of its larger size, peculiar shape and straw colour: it is always constructed of tall-growing reeds brought from Hammar lake, which have the thickness and strength of an ordinary garden bamboo. The exterior of a madhif might suggest a fanciful tin tabernacle of the Free Churches done in straw by natives of the Congo, but on entering it the impression received by the long, smoke-blackened tunnel was more joyfully reminiscent of an Underground station stripped of the advertisements. By contrast to the blinding sunlight the apparent darkness was more illusive than real; as the eyes became accustomed to the change it seemed a pleasantly tempered light, as restful as the temperature was refreshingly cool. Down the sides men squatted on mats; in the centre was the coffee-man's hearth and line of bright brass pots; from the hearth rose a wisp of smoke to join the bluish haze that hung under the roof. On entering it was polite to intone the greeting "Peace to you", whereupon a general uprising took place and in unison it was returned by a solemn rumble of voices, "And to you peace". At the far end carpets were spread and easy-chairs arranged along both sides and the end wall. When everyone was seated other greetings were given in ritual order, then the coffee-man came forward to pour some drops of bitter coffee into one of the small cups from the nest of three or four held in the left hand. Three times the cup can be replenished, then the coffee-man moves to the next man, and the guest sits back in his chair until he is mildly surprised by being offered a triple succession of glasses of strongly sweetened tea, followed again after a few minutes by more cups of coffee. As the bitterness and the sweetness excite a thirst, a bowl of water, scooped from the nearest ditch, passes from mouth to mouth.

Thus many hours were spent in company, drinking, talking and smoking the long thin Arab cigarettes. After a time often I was seized by the acute restlessness which I felt as a small boy when I went with my mother to a sewing meeting at the Chapel. An Arab who noticed this and could speak some English would be sure to say, "Sir, please take your rest," and plump half a dozen more cushions around me.

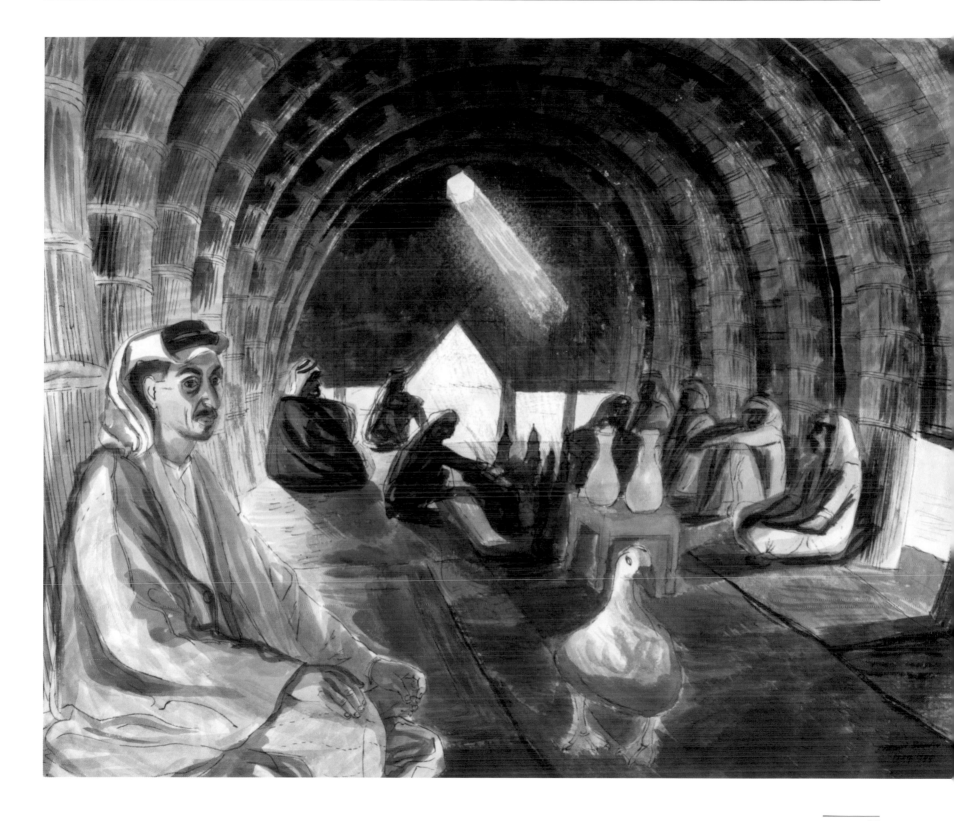

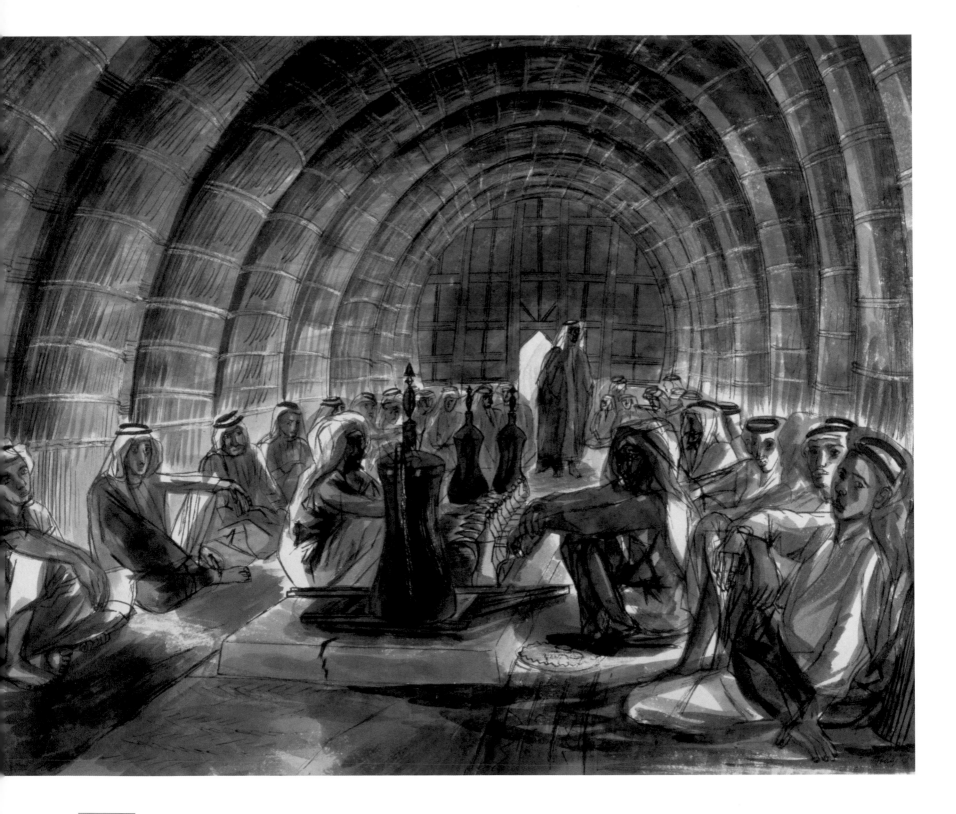

Opposite:
30. Interior of Sheikh Muzhir al-Gassid's Mudhif

The first day at any new place was given up to resting, also trying, with the help of Mohammed, who had acquired a slender vocabulary from me, to sustain an intermittent show of conversation. Questions were asked unless it was deemed polite to ask none, though unblushingly I set an example by asking many. Their questions followed certain lines: Why didn't I speak Arabic – it was easy to learn? Were there Moslems in England – how many? Did we use camels, grow rice, etc. – why not? What tribes lived in London – and did I know their sheikhs? Except by effendis or men who had had a school education the natural assumption was accepted that life in England, being of a tribal character, conditions were much the same as in Mesopotamia or elsewhere in the Near East.

Waiting for the evening meal was the social occasion of the day. Men came at sundown to take their places on carpets laid down in the form of a square, on a sort of open courtyard where the sheikh presided. Neighbouring men of importance with a few armed retainers came in when word had gone round: it was an obligation. The social occasion was anticipated – was it not of daily occurrence? – and the sheikh busied himself beforehand, with a womanly care giving directions for the laying of the carpets. Each man gave the usual, general greeting, then his equals stood up until he had squatted upon their mat. The arrival of a sheikh threw the whole gathering to its feet, visitor and host would rub hirsute cheeks, and he would be led to the best carpet. When darkness fell an antique lantern would be lit and placed at some small distance from the company – a necessary precaution, as it attracted a winged

gathering of its own: thousands of midges danced round the light and swirled upwards like smoke curling from a bonfire; a congregation of extraordinary insects crawled in the lighted patch on the ground, the praying mantis, stick insects, black horny beetles, and, as if sensing fun, frogs and toads came hopping from all directions to join the geckos, and a cat or two pawing and chewing moths.

A hundred men or more had now gathered and were talking in the half-darkness. The daytime heat had gone; a light breeze moved the air, which was still hot and sticky. Overhead was a faint starlight but the darkness around was very real; and from that dark and watery limbo came the incessant croaking of frogs, a harsh snapping sound like that of dogs barking afar off. It was getting late. Then I noticed a group of men and boys had risen and was walking off to the harem; a sign that the meal was ready. A sheet was spread as the men and boys returned. The procession was led by five men staggering with the weight of a pan of rice, on which a whole boiled sheep had been laid; other men followed carrying dishes of rice and sheeps' heads, boiled chickens, roast fish, curries and gravies and vegetables, sweet ground rice and sweet spaghetti and fruit. The pan of rice was placed in the centre, around it a circle of rice and sheeps' heads, and then the remainder in between until the sheet was covered with plates touching rim to rim. The ewer and basin was brought for washing hands. The sheikh called the men of the first sitting individually by name. The circle of men sitting on their haunches ate in silence, and ate rapidly, using only the right hand. The sheikh did not consider it polite to sit with his chief guests; instead he sat

Opposite:
31. Sheikh Raisan al-Gassid, brother of Sheikh Muzhir al-Gassid

at my side and dropped an abundance of tit-bits on my plate, sheeps' ears, chickens' legs and lumps of fish, so that all I need do was to grope and identify by touch the sweet from the savoury. The first man to finish and stand up was a signal for all to stand, but seeing my slowness a polite delay ensued; a guest of honour may stay a few minutes alone, indeed he is urged to do so, but he ought to hurry. I washed my hands and sat off-stage to watch the subsequent sittings: three or four finished in turn, the average sitting lasting six minutes, but the last of all and most impressive was that of the boys, who came quietly and quickly took their places. By the age of ten a boy has acquired all the dignity of his father; there was no scrapping or play or talk among this small party, nor could I see signs of greed; tit-bits were handed around as they were among the grown-ups. The meal over, the sheet was shaken, and what remained, mostly rice, went back to the harem for the women.

The date gardens surrounding the madhif of Sheikh Haji Farhud Al-Fandi formed virtually an island – an island under water in the middle of a temporary lake made by the floods. Water swept along the waterways, but under the dates it was stagnant and weedy, the home of a multitude of frogs and water-snakes and terrapins. By jumping ditches and stepping precarious bridges (a palm trunk dropped from bank to bank) it was nearly possible to walk round the perimeter as a fly might on the rim of a saucer; but the path was narrow, often a ridge of clods upon which it was necessary to use circumspection rather than the arrogance of a cat trotting along the top of a brick wall. Any ridge that led a path in among the trees

was certain to go to the huts of the cultivators, to places it was undesirable to visit such as women's quarters, and it was evident that these were guarded by fierce dogs. Outside the perimeter lay shimmering sheets of water, from the surface of which rose a misty steam, producing with the intense sunlight a painful glare, and with the heat a bathroom humidity. Boats glided over the glassy surface, and many birds, egrets, herons, ducks, pelicans (called by the Arabs the water-goat), were busily fishing.

The scenery was most attractive, but it did not differ in essentials from that which surrounded the madhifs of Sheikh Muzhir Al-Gassid and his brother Sheikh Raisan Al-Gassid, who lived on the other side of the river. These two brothers and Sheikh Haji Farhud were sheikhs of the Hatcham tribe, and in 1935 when Sheikh Raisan was in rebellion against the Iraqi Government, he and his brother Muzhir and Sheikh Haji Farhud were all held in captivity for a period. Sheikh Raisan Al-Gassid is now a Deputy to the Iraq Parliament.

Five hours down the river by mash-huf lived another important sheikh, who for several years had been a Deputy to Parliament, Sheikh Hammuda Al-Muzai 'il, the paramount sheikh of the Hasan tribe. Here the country was more open because of fewer palms and greater floods of water. Of dry ground there was not much to be seen, even less for the stranger to stretch his legs upon, merely a platform for the sheikh's madhif and diwaniah, and behind for a mud-built harem, a four-square windowless building in which the womenfolk lived. Close by the madhif ran a tributary of the

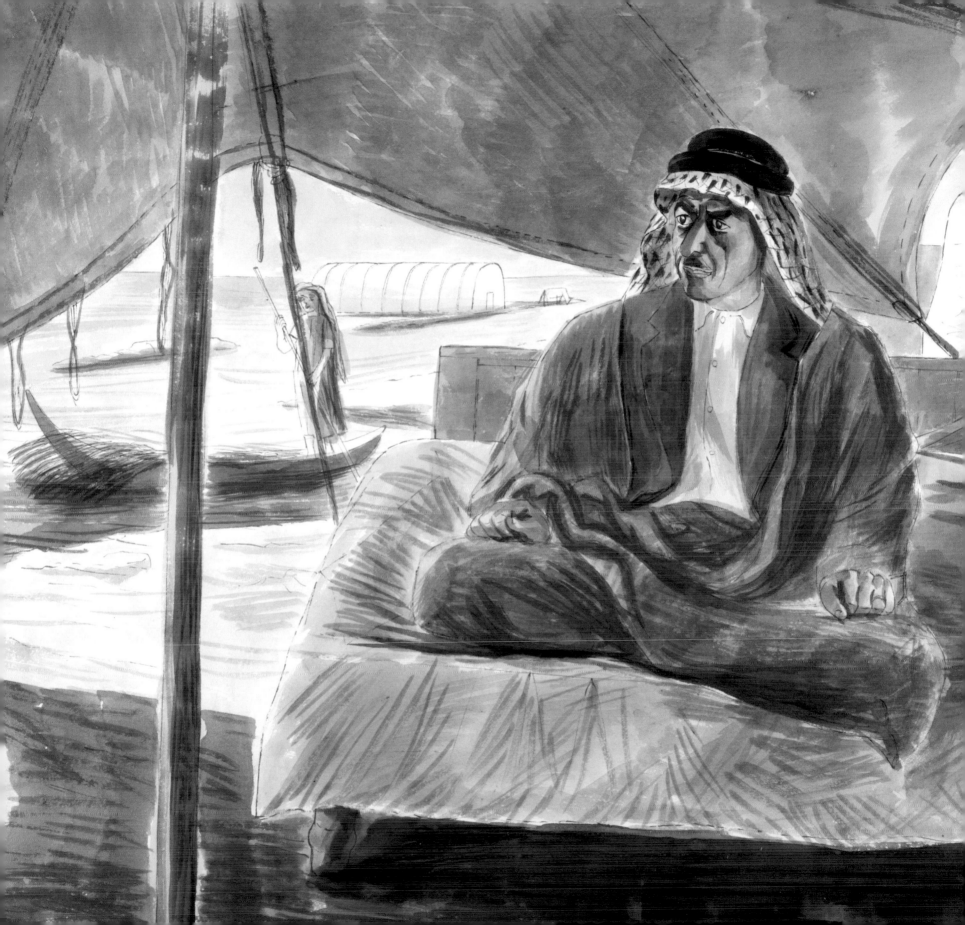

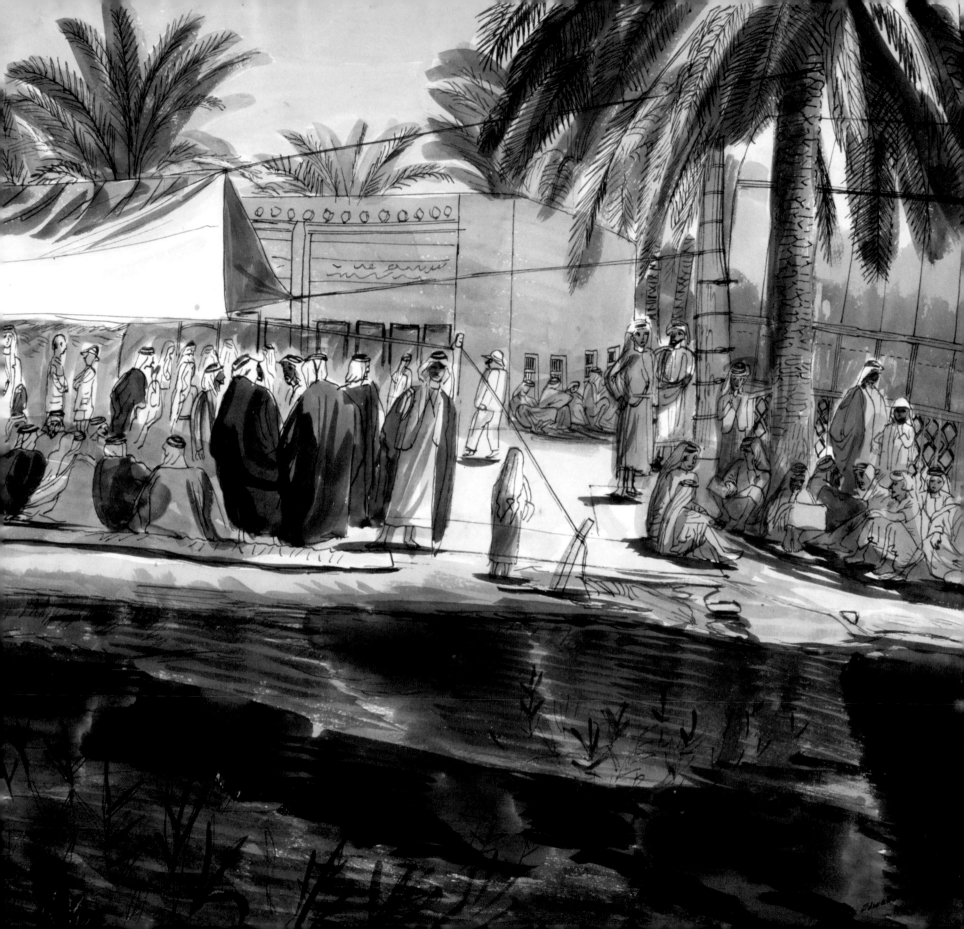

Opposite:
32. Sheikh Haji Farhud al-Fandi, Hatcham Tribe, Preparing to Entertain

Euphrates from which water was drawn into the nursery beds for the young rice plants; later, when the floods subsided, these plants would be pricked out and put into the soft mud of the fields; but now the mat of grass-like leaves was a brilliant green, and here and there a stake had been thrust into the beds, and upon it a turtle hung, impaled as a warning to others of its predatory kind. Another common sight was men lining the river-bank at certain hours holding fish spears poised ready to strike; elsewhere a solitary man might be met at dusk wading waist-deep in the shallower water where poisoned bait had been thrown to induce fish to float conveniently to the surface in a fuddled state.

From Sheikh Hammuda I went on to Sheikh Haji Maktuf Al-Haji Hasan, the sheikh of the Albu Khalifa tribe. From this sheikh's village there was little to be seen except water; it stretched away across Hammar lake towards Basra in an unbroken sheet for seventy miles; for three-quarters of a circle the skyline was a taut straight line dividing a waste of waters from a cloudless sky. To get from the sheikh's collection of reed huts to the village of Hammar meant crossing twenty miles of intervening water, a risky journey in a mash-huf unless made in still weather. Besides it took more than thirteen hours. So I was glad to accept the offer of a launch to be sent down from Suk esh Shuyukh, and even in this the journey took a long time. The countryside had now completely changed, a predominance of palms had given place to that of water. It might have been a branch of the sea, there was nothing of near interest to attract attention, only pelicans and faraway strips of palm-fringed land that moved with an imperceptible and dreamy slowness.

At Hammar a fine crowd from the market gathered to watch me land; a young man, his hair standing on end, helped to pull me up the bank and, to my surprise, said in a shocking accent, "'Ow are yer?" He was the village schoolmaster who taught English, and this being a great day for him – I had no need to take his word for that – he displayed himself and me to public advantage, delaying progress to my host, Sheikh Sharif Al-Hadi of the Bani Hutait tribe, by organizing a detour which included the market, the police office and the school. When I was allowed to be taken by mash-huf to the promontory on which stood the sheikh's madhif other boatloads came too, in one the entire Police Force comprising a corporal whose hair had been badly dyed bright orange with henna, and a lumpish constable who smiled; in another boat the three masters of the school, in others parties of Arabs. My five days were marked by an excessive show of friendliness.

I travelled to Chebayish with the Mudir, who turned up one morning early, before dawn. To reach Chebayish took five hours and for much of the way the boat had to be poled through narrow channels in the reed-beds; the reeds standing seven feet out of the water hid the view, and worse, stopped the least breath of air, canalizing the humid heat so that for us in the boat it was nearly unendurable. Sometimes in occasional open patches of water a few reed huts were passed, built upon small rafts, floating settlements that in a high wind moved with the 'tide'. The rafts were made by laying down bundles of reeds in the shallow water and building up to surface level – perhaps five or six feet – and steadily laying down more reeds on top just as fast as those

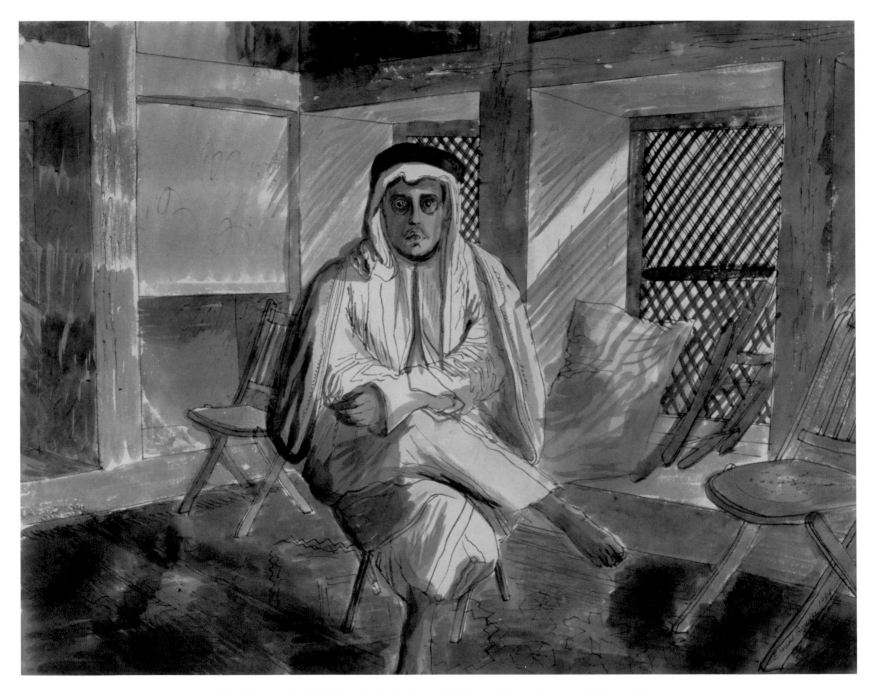

33. Mohammed bin Abdul Asis ibn Mardi, Emir of El Khobar, Dhahran, Dammam, Qatif and Jubail

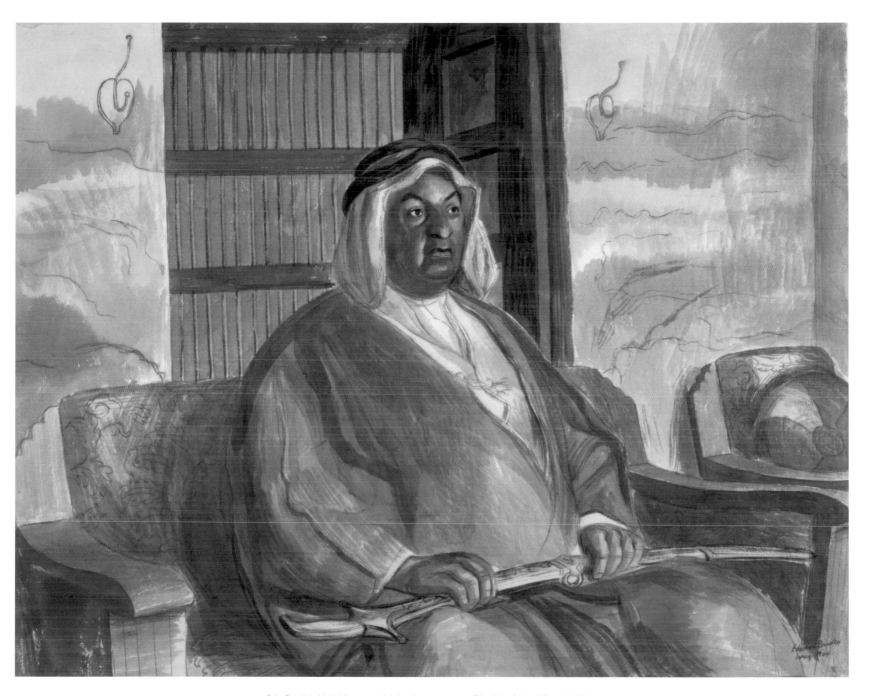

34. Sheikh Haji Khaiyun al-Ubaid, paramount Sheikh of the 'Ubudah Tribe

beneath became compressed and allowed the water to seep through. On each raft a hut had been constructed by tying reeds together on the lines of a four-poster bed and covering it with reed mats. This was large enough for a family and one or two cows and any number of hens to muck-in together and share their bugs and fleas: by any standard of living it was a wretched life in that fearful humid heat. Water buffaloes up to their snouts in water lived in decent luxury. Nearly all the children were naked, perhaps sporting in the water or helping mother pat pancakes of freshly fallen cow-dung to be dried for firing, doing some other small job or sitting about listlessly. One poor little fellow, a deaf-mute syphilitic idiot, nude as the other children were, to whom Mohammed gave a cucumber, could not eat it and express his delight at the same time; he lost a lot by dribbling it down his stomach while making raucous, bestial cries of pleasure.

Chebayish, the centre of the woven reed-matting industry, was a large township having no roads, or rather one only through the market to which people moored their boats. The madhif and huts stood in isolated groups, entirely surrounded by water, but crushed together with the dwellings were masses of vegetation, palms, blue-gums and immensely tall reeds fifteen feet high. In a boat drifting down any of the broad waterways through the town, the glimpses seen of straw-coloured houses, through dark trees and the blackish-green reflections of these in the still water created an ideally lovely combination. Chebayish had a character of its own; also it had a climate so severe that I was persuaded to cut my stay as short as possible and return to Nasiriya.

My second visit to the Marsh Arabs was of longer duration and a more enjoyable experience. But again, as on the previous visit, I was impressed by the Arabs themselves, by their good manners and simple dignity, above all by an amazing sensitiveness to friendship which seemed to draw no intolerant line between differences of colour, race or religion, but, as with conversation, tried to ignore the existence of a barrier. I hope some day to meet these good friends again, to whom on parting the words were "If God is willing".

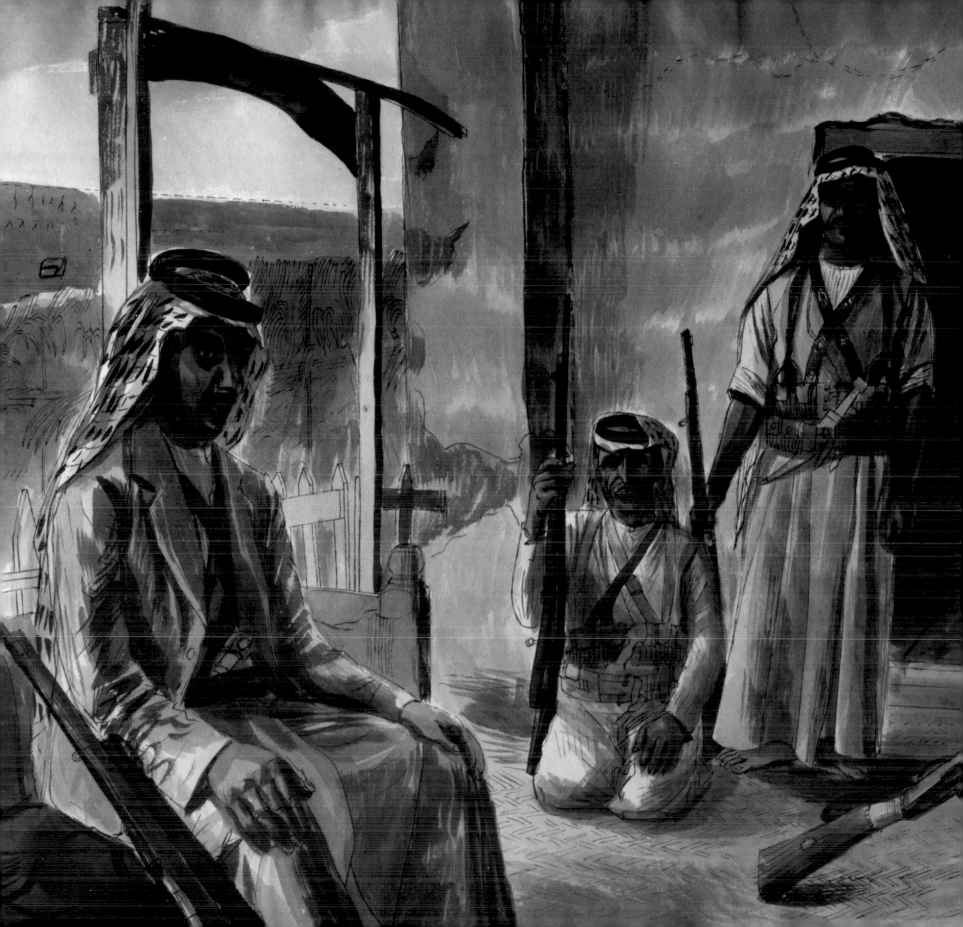

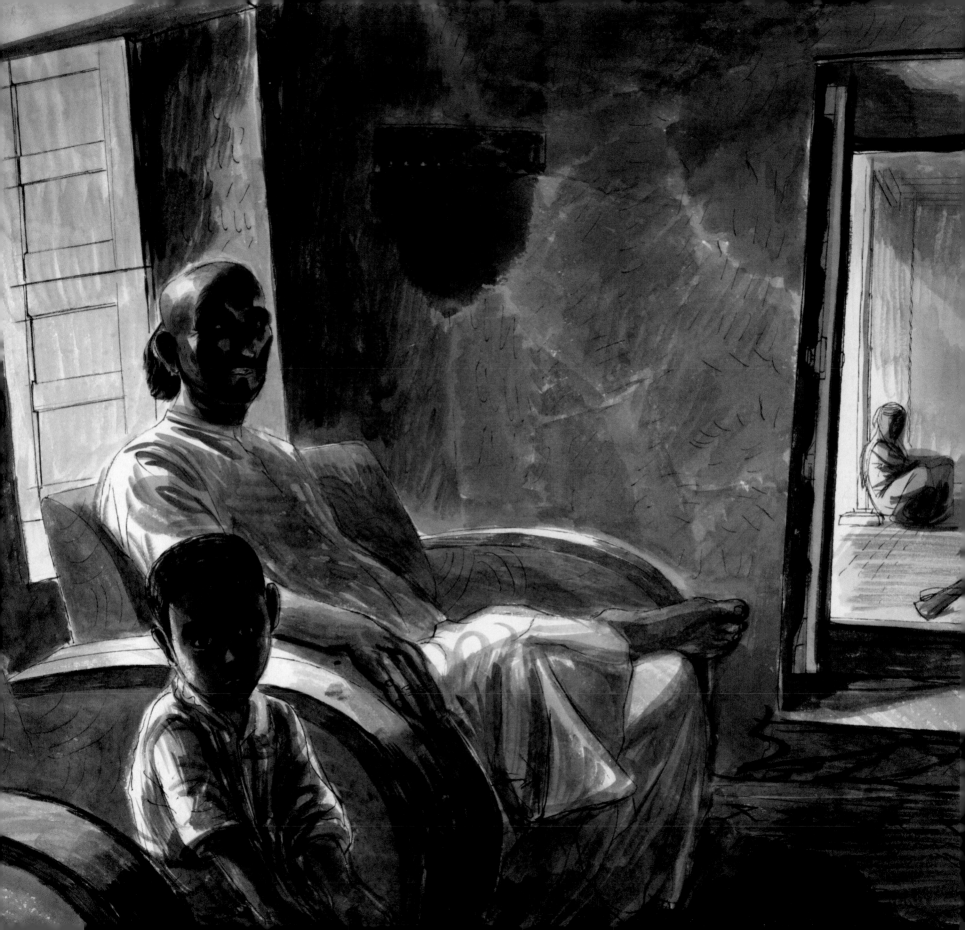

# AN ARABIAN JOURNEY
## GEOGRAPHICAL MAGAZINE
## EDWARD BAWDEN

*Some months ago the author as an official war artist accompanied members of a British Anti-Locust Mission to Arabia. But what he describes in his article is simply the things that were of interest to him personally: the things, as he himself has said, that he would care to write home about.* The Geographical Magazine, *May 1945 Vol. XVIII No.1*

Seen from the air the coast of Arabia revealed a barren waste. It was like standing over a large map spread out on the floor in sunlight, the greater half coloured ochre to represent what seemed to be an almost featureless desert and the other half deep blue for the sea, the two parts joined by a sharp but fairly uneven line which might have been drawn by a pen. The town of Jidda showed as a hard, white, shape against the tawny colour of the desert, no greenness of gardens or fields softened the contrast and the few isolated buildings did not blur the effect of its compactness: in the harbour were many small boats, and the minaret of a mosque drew attention by its similarity to a lighthouse. Rapidly the plane lost height and as rapidly the town gained in size. Now the plane dipped a wing as it flew in a circle over the airfield, and as I gazed down on Jidda I had the impression that a paper model on a drawing-board had been tilted up to show the distinctive buildings; then the plane swung down in a long sweep towards the landing ground, it touched the sand and Jidda fell away to a horizontal strip of walls overtopped by tall, narrow houses.

The local headquarters camp of the Anti-Locust Mission was in the hills fifteen miles from Jidda. In appearance it was similar to that of any transit camp in the Western Desert, but the setting had a grim character of its own, seen against the morning or evening sun the low hills were like coal-heaps on railway sidings, nor at midday, when the light was overhead, did the leaden colour of the rocks, fused with dull red or grey-green, look at all gay. The rock was hard but loosely held in place, lumps of it could be broken off any of the numerous outcrops, and as a consequence the slopes were not excessively steep though the loose litter of sharp-edged debris made climbing hard work and the effort unwise in shoes soled with Egyptian leather. There was a sparse, not very lively growth of desert scrub now at its best because the rains had not quite ceased; and a few adult locusts with the distinctive yellowish green colouring of the mating season taking quick, uneasy, darting flights whenever they happened to be disturbed.

The camp had been recently moved under the shelter of the low hills, because its former position on the open plain had given no protection against the frequent, sudden gales of wind. One of these swept over the camp while I was there. I was sitting in the tent when invisible hands took hold of everything and threw it out, clothes hanging on a line strung between the tent-poles passed over my head and many sheets of drawing-paper streamed away. Instantly the wind gathered strength. Ropes of sand swirled along the ground, rising into the air as the force of the wind increased: within the tent, sand piled up over the kit. One of the tent poles snapped, a lucky fluke that saved the canvas from being blown away, as what remained standing rode the storm better since it acted no longer as a wind tunnel. For ten hours the storm was pretty violent and not every tent survived intact.

Previous spread:
36. Sheikh Hammuda al-Muzai'il

Jidda surprised and delighted me – it was so different from any other town I had seen in the Near East. The tall, narrow, tower-like houses grouped together had a fine architectural beauty. The nature of the building materials used, the large blocks of coral rag for walls and the Javanese teak for window frames and shutters, produced a different type of house from anything that could be slapped up in mud or put together with bricks; it accounted for walls being nearly as massive as those of a 14th-century Florentine *palazzo*, it gave the surface an agreeable plain texture and the silhouette of the towers a sharp, crisp line, but it did not explain how good proportions and an elegance of detail had been achieved – unless it was due to the method of working, of varying a traditional style in accordance with the need, as well as allowing a building to grow in the hands of skilful workmen instead of making it conform to measurements upon a piece of paper. In style these houses had a pleasant plainness; the ground floor was especially plain in character, conceived for strength and protection, yet the floors above as they rose one above the other progressively burgeoned into richer workmanship; carvings and mouldings on the elaborate window embrasures, window hoods with lace-like edgings, and screens of lattice in front of the four or five rows of sliding shutters made a pleasing, and in disrepair, as they more often were, a picturesque addition. These window embrasures projected from the wall surface singly, or a row of them might be joined vertically to rise like an organ loft to a frilly, pipe-like decoration at the top. Three, four, even five floors high, the houses stood alone or in groups, placed with a haphazard disregard of forming streets, but shutting in any number of narrow

lanes. It was exciting to stand on a roof at dusk and peer down into the lanes where a few dim figures moved in the gloom, and cries came up from below, a man urging on a donkey, the bark of a dog or a goat's bell tinkling. At first the setting sun touched the far-away hills, then the tops of the houses, but as the fringes of the golden curtain of light were pulled aside a silvery clearness was left in the air. Now the sky was drained of colour. For a time objects without shadows retained a ghostly semblance of form. Then night came on swift wings over the desert, and dropped, blotting the town in darkness except where a lamp over a doorway cast a feeble ring of orange light.

Plans had to be made for the journey across Arabia from the Red Sea coast to the Persian Gulf, and these depended upon making use of camps established by the Anti-Locust Mission. On the map a few short, straight lines might be drawn linking Jidda, Yenbo, Hail, Buraida, Rumaihiya and Dhahran, but on the face of the earth these journeys from place to place were to be neither short nor straight. Mecca and Medina were out-of-bounds, and, perhaps a peculiarity shared by no other country, also the capital, Riyadh. Arabia is said to possess no rivers, nor by a stranger freak does it appear to have any roads. To travel by any other means than on foot or a donkey is by knocking about on a slow, bone-shaking camel, but the Mission had cars and they kindly lent one of them, together with the services of an Army driver, to the party of which I was a member, consisting of a journalist and a photographer. The two hundred and thirty miles to Yenbo could be done in a day. The

track was no more than that made by the combined wheel-marks of other cars and that first taste of what travelling might be like made me keen not to retrace any part of a future journey; for most of the way the rough, bumpy ground threw us and our kit together intimately, with too infrequent 'breathers' as the car ran across stretches of firm gritty ground.

The camp at Yenbo was on a saltmarsh several miles from the town. Next day when Mohammed, my Sudanese man, came from Cairo, he was not very pleased to be turned into a sick-nurse. After five days in bed with malaria I was allowed to walk as far as the seashore where the long-legged crabs, spry creatures on the alert, held up their large claws in a defensive gesture if they were alarmed and scuttled off sideways on the other six. But the saltmarsh was a sad, desolate spot with little growing on the salty sand, except a few repellent shrublets and a kind of sea-lavender. The town of Yenbo also did not compare in size or interest with Jidda: it had a scattered, rather forlorn, secretive air within its walls. But it happened to look lovely as I was leaving it in the evening, a low-lying dark silhouette against the red bars of the sunset on the level, empty arms of the shore; in the lagoon outside the town one solitary living thing, a flamingo in the still, shallow water was fishing with decorum.

The track from Yenbo as it went inland to Hail passed through Medina, but the Mission had to avoid the Holy City and did that by making a detour to the north of it on a radius of twenty miles. By the direct route camels were said to take fourteen days: by the

circuitous route used for vehicles it took five days. Arab Guides sat in the leading vehicle of the convoy, trustworthy men who had been appointed by King Ibn Saud to serve with the Mission, whose job it was to see that the convoy did not go astray and that no ill-feeling was shown by countrymen who had not met Europeans before. These Arab Guides were a fine set of men, of good physical appearance, in behaviour friendly and courteous, and several of them were attached to every camp under a Head-man or Emir. By using jeeps the five days between Yenbo and Hail might have been shortened, but we were with a convoy of 10-ton trucks carrying sacks of locust bait and supplies of rations, so necessarily the pace was not fast. It was difficult terrain and the heavily loaded vehicles had sometimes a spot of trouble on rock-strewn ground or loose sand; the track itself, hardly more than one in name, served no other good purpose than that, like an ever-unrolling ball of wool, the most devious coils of it could be followed as it twisted around the Hejaz hills. It was an early mountainous countryside, extremely wild and rocky, entirely arid, as desolate and forbidding as though a great fire in a past age had burnt up every sign of life, leaving the piled-up rocks blackened by smoke or scorched to a dull red glow, with veins of vivid colour where the heat remained. The scenery had a grim sort of grandeur.

By the end of February Arabia was not blazingly hot; at midday the sun was warm but the nights got colder inland on the plateau two thousand feet above sea level. The weather was a surprise. In the first hour at Hail we were waiting hungrily for dinner when

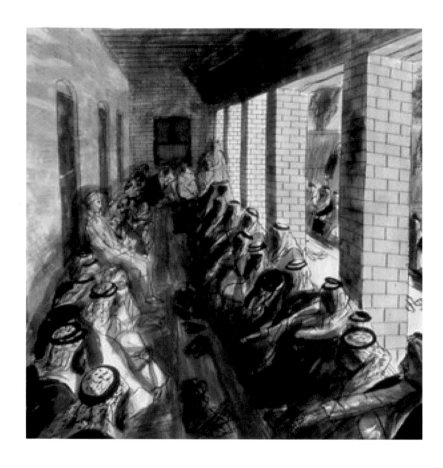

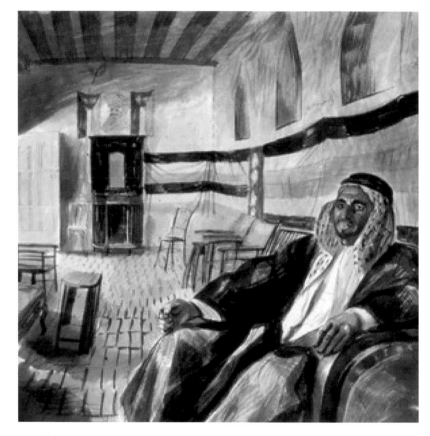

Left:
37. A Majlis of the Sheikhs of the Southern Desert held
by Major CSJ Berkeley: the local Political Adviser (Detail)

Right:
38. Sheikh Haji Farhud al-Fandi of the Hatcham Tribe (Detail)

Opposite:
39. Sheikh Wabdan al-Sa'dun and his brother Jabir (Detail)

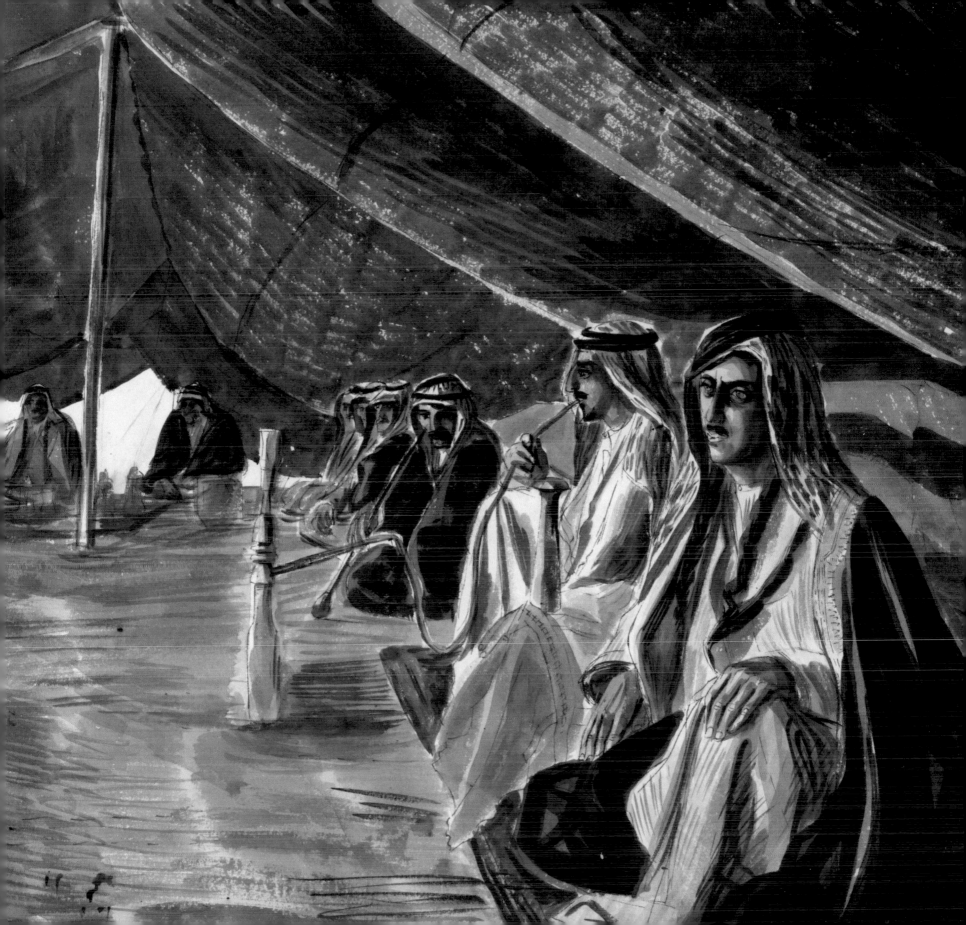

someone called out that a sandstorm could be seen. In the fading light a dark barrier was clearly defined against the dim smear of the sunset: it swept forward with lightning speed and I had a glimpse of what might have been the swirling smoke of a hundred rapidly moving bonfires. The tent rocked violently. The hanging lamp swung with an erratic motion and cast a spotlight that did a dance in the dense fog of dust. Heavy rain followed the blowing sand: then there was a lull. Flashes at night gave a foretaste of another storm. The tent partly came down. In the small hours the tent-pegs were wrenched again from the sodden earth, and it took three hours' work in an icy wind to save the tent. Then it was I noticed the ratel, or honey badger, sneaking for cover into a pile of stores, but for us with our beds on the ground the chances of a flood was a more anxious thought than the companionship of a very fierce little animal. Next morning the ratel was caught and put back in the box, in which, so it was hoped, it would travel to London as the first visitor of its kind.

Hail, unlike Jidda, was a purely Arabian town: in general appearance there was the greatest possible contrast. Jidda with its mixed Eastern population exhibited differences of dress; and an Indian influence, using the word in an inaccurate sense to include Java and Malaya, was traceable in the architecture – one instance being the bizarre ornamental vases on parapets and gateways. At Jidda, if foreign influences were reflected it suggested a certain amount of cosmopolitan freedom or laxity, but that is only what might be expected at the pilgrim port used by the Moslem world.

Everything conformed to strict standards at Hail, foreign manners and ways were not welcomed, and as an indication of this we were asked not to be seen smoking in the streets. Therefore there was conservatism, noticeable at once in the architecture; the houses were of mud without the least trace of decoration, either in the use of fanciful details or with paint and carving. Mud has pleasing qualities when it is recognized that its charm lies in its simplicity, in the 'batter' given to walls and in a fat roundness of form allied to what can be modelled in clay by the potter's hand. Large-scale work does not detract from its merits, rather it enhances them. For size the most impressive buildings at Hail were the Emir's Palace and the Barracks, two enormous mud fortresses with towers; together they stood alone on the outskirts of the town, and looked magnificent from every view, especially seen against a range of bluish-black mountains that had a toothed edge as unexpected as the wavy red line of a seismograph. My only glimpse of the interior of the Palace was caught as we were being ushered to an upstairs room for an interview with the Emir's Deputy; as we were taken along a passage, up a stairway and across a landing I saw a courtyard dazzlingly bright with whitewash, exquisitely simple and clean. The small room in which the brief interview was given was heavily carpeted, so too were the wooden pews around the walls; all else had a puritan severity, unless the words "made in Japan" in large letters on the calico stretched taut over the ceiling or a helmet of the same material hung around the top of a stout column could be called decoration, though it was decorative certainly. As the Emir was on a hunting expedition his Deputy agreed to send a wireless

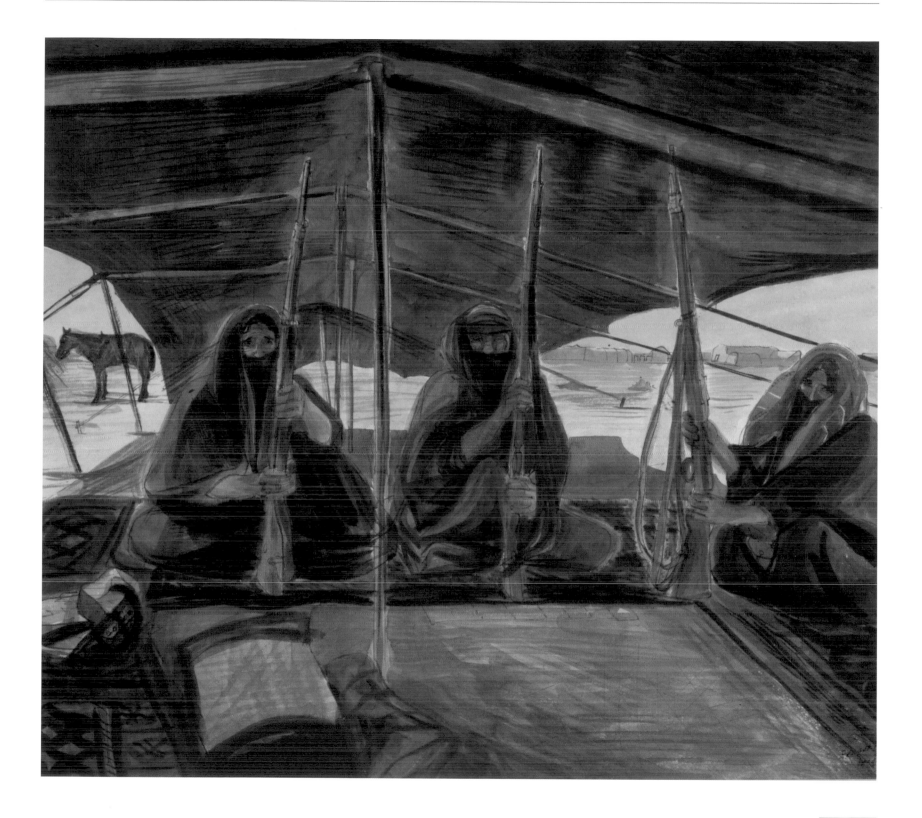

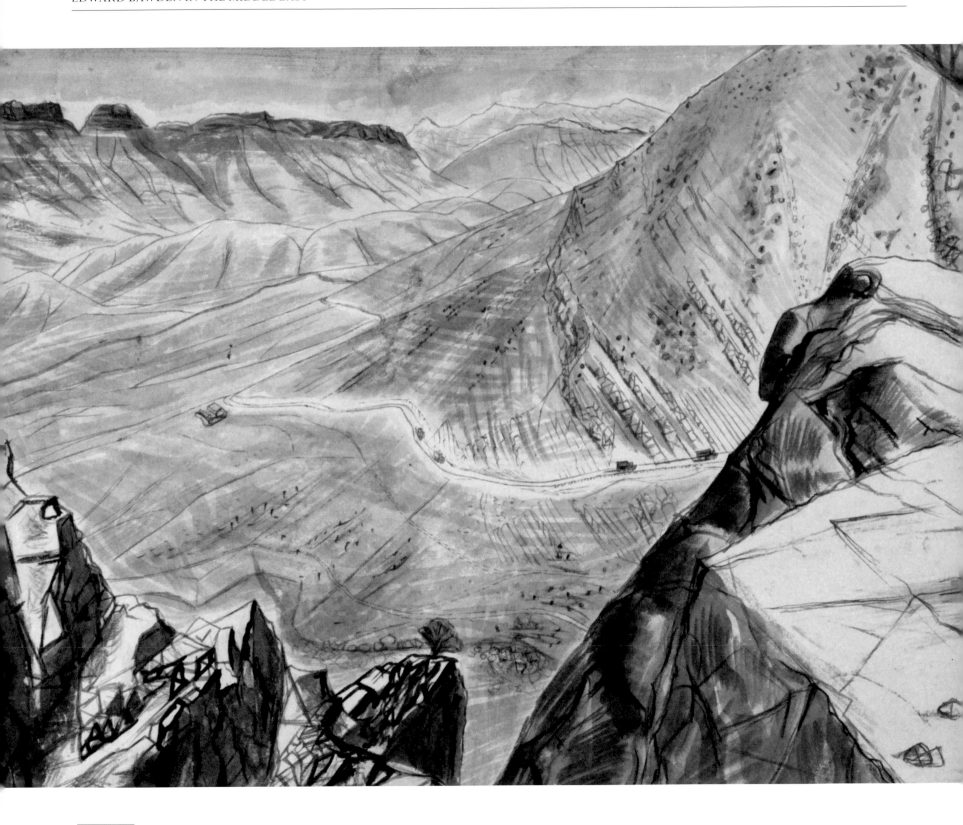

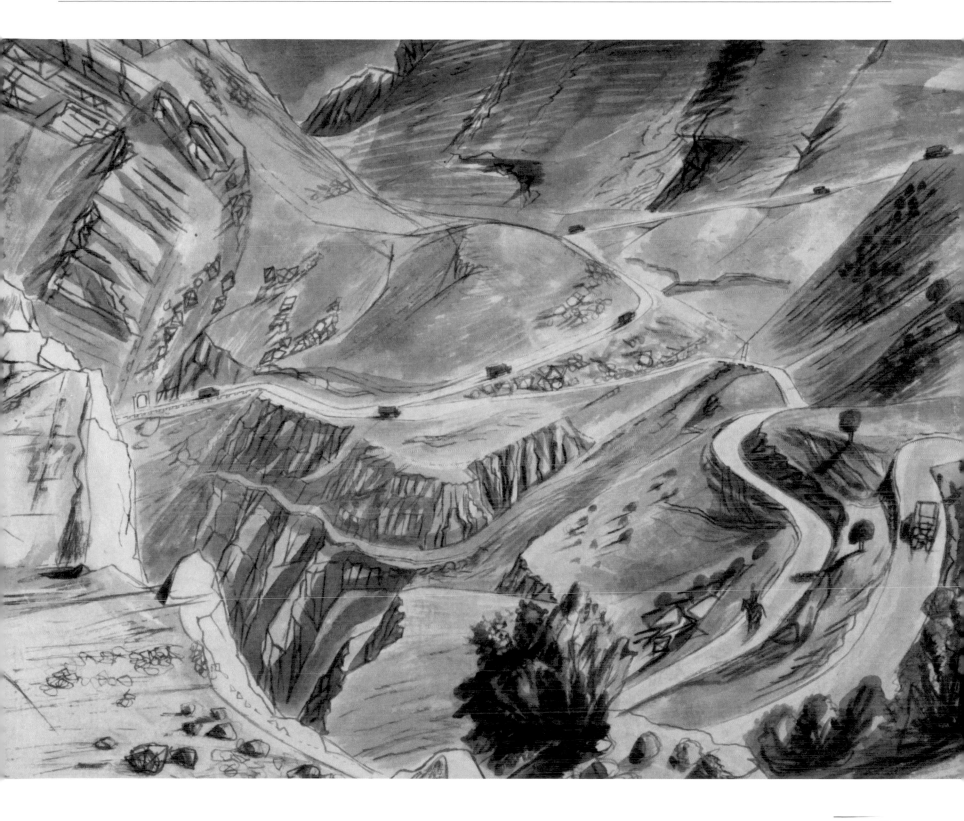

Opposite:
42. Aid To Russia: The rail-head at Khanagin, Iraq

message, and two days later I was granted permission to make drawings in the town but not to do so within the Palace. While living in the town I noticed the slim pole of the aerial and thought it a strange, though useful anachronism to find in a place otherwise so lacking in Western amenities.

To live in an Arab household exercises the humdrum virtues of patience and forbearance. From five in the morning when flies begin to tease until nine or ten at night when the fire on the coffee hearth dies down the time passes with dignified slowness, punctuated by the passing of coffee cups and the hours for prayers, the two diversions. For the rest, like Mr Eliot's Gumbie Cat, one sits and sits and sits, uncomfortably cross-legged, until the sitting part gets sore. Salem, the Arab Guide in charge of the Rest House, kept a strict eye upon me. I was not allowed to leave the house without having him as an escort. On a visit to the Camel Market, a very lively spot where every kind of animal is driven and humans foregather to gossip, I noticed that Salem bought at a shop a strong, whippy camel cane. He strode ahead of me, a lean, energetic little man scarcely five feet high, but I thought that his stride showed a determined jauntiness. On one side of the market-place were the towering ruins of the Palace of the expelled Ibn Rashid family – that, and the excitement of the market, was an attractive scene. After working for a short time I looked up to find myself walled-in by quite a big crowd, beautifully graded, the smallest boys in front, taller ones behind and then the grown-ups – all of them silent with wonder! It seemed a shame to make an impatient gesture of annoyance. Then Salem,

like a wicked fairy with a wand, sprang into action and whipped the people from my line of vision as though they were a number of intractable camels. This disgraceful clearance had to be made so frequently that I did not care to repeat my morning's experiment elsewhere in other crowded parts of the town.

Hail lay to one side of the plain where the hills on each side came near enough to make a bottle-neck half a dozen miles wide. On the side of the town that faced the range of bluish-black mountains with the fantastic, serrated line of peaks there was an open expanse of sand, but behind, beyond the Camel Market, the town ended with houses scattered among the date gardens and fields; and these shaded off towards the slopes of hills, while a broad green band of them flowed up a valley out of sight. Whenever I took a walk near the gardens I always heard the creaking of pulley wheels on the scaffolding above one of the many wells. Usually a pair of camels would be doing the work. The goatskins were drawn to the surface as the camels walked down a steeply inclined ramp contrived to lessen the labour of pulling; as they turned at the end of their walk the goatskins were tipped into a trough (covered with branches of palm to prevent splashed water being lost), and from the trough the water ran into an irrigation channel feeding the fields; then as the camels walked back up the inclined ramp to the well-head the empty goatskins went down on slackened ropes. Another common sight were small encampments of beduin living in black camel-hair tents, and these, without the need of making an inquisitive inspection, looked as if the domestic life in them might be squalid.

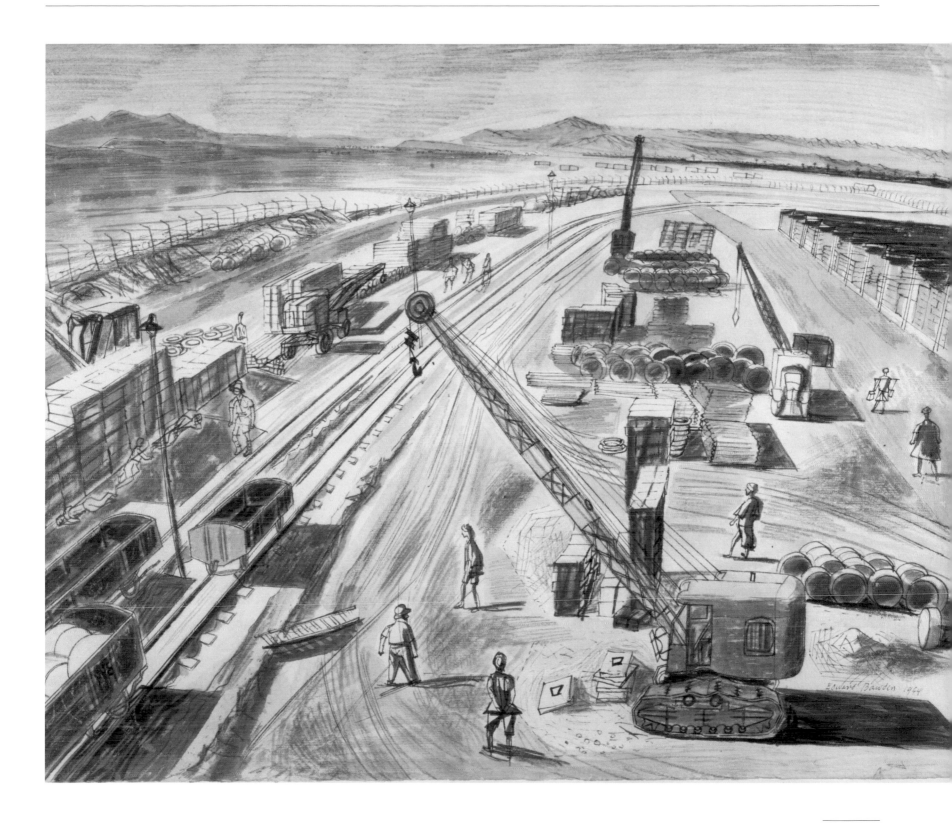

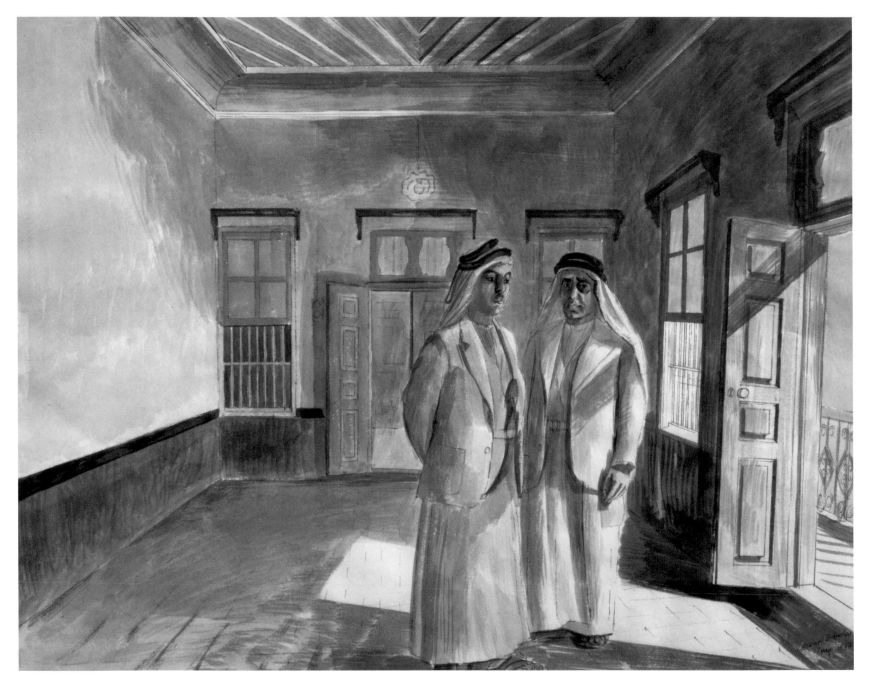

43. Two of Sheikh Haji Khaiyun's servants

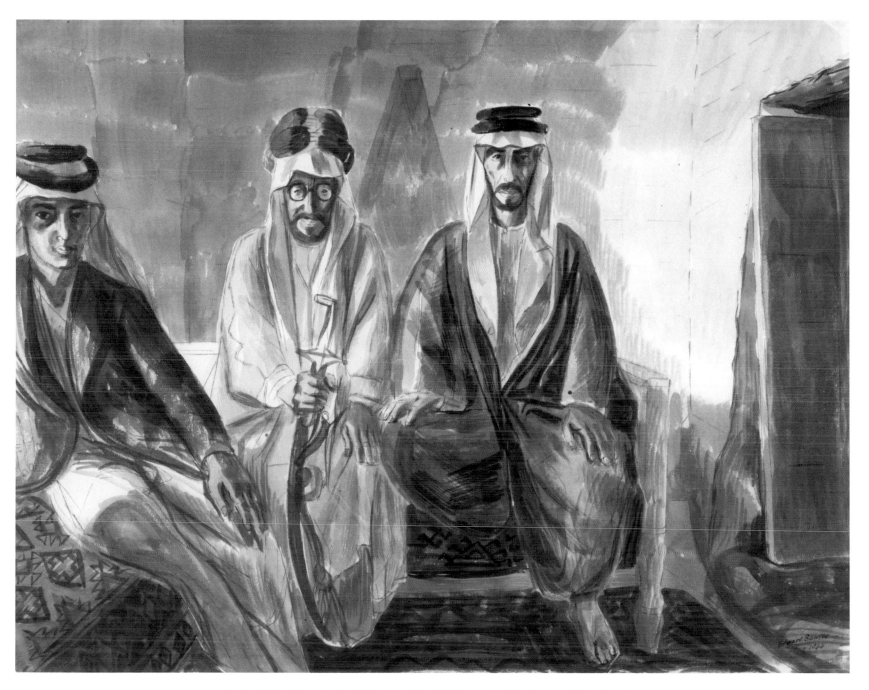

44. Sayid Abdul Husain, Sayid Hamud and Sayid Mohammed of the Hassuna Tribe, Iraq 1944

At Jebel Salma, thirty-five miles from Hail, there was an operational camp belonging to the Mission. In tents pitched on the Emir's grazing-ground some Sudanese, Palestinians and Syrians were living under the charge of a British corporal. Besides liking the friendliness of the camp I found the scenery attractive. Two miles away ran the cliff-like escarpment of a line of hills, in the main a fine tumble of giant boulders and unscaleable, smooth rock surfaces. That was not very extraordinary; the surprise was the occurrence of clear running water, icy cold. The spring rose in a tiny cup-shaped valley higher up; the rivulet then percolated through the hillside and dropped as a miniature waterfall into a series of rock basins, and trickled away among lush herbage to disappear in the sand less than a hundred yards from the foot of the rocks. A bathe in this icy water was not repeated. Animal and plant life was abundant, birds were numerous: gazelles, jerboas, ravens and eagles could be seen. One evening at supper we were surprised by swallows being very energetic overhead; then it was noticed that termites were taking the connubial flight, but every time the feebly-flying insect managed, after a fussy hesitation, to get into the air it was caught unerringly by a beak that snapped to with a click. Next evening a gathering of dragonflies repeated the performance of the swallows, though it was impossible this time to detect the victims. And again on the third evening wagtails came in their turn and were busily intent upon clearing the ground of something.

From Hail to Rumaihiya was five days by car, broken by one day spent at Buraida. This stretch of countryside was open, undulating desert, the travelling across it made easier by firm stony ground and less often difficult by patches of loose sand. Of Buraida I have only a faint memory. We were conducted through the market-place and several of the streets, followed by an unusual number of boys of all ages, who turned up again next morning in such an uncontrollable herd that the photographer came back in despair. One street I did remember, a covered bazaar where branches of palm had been used to provide a very pretty arbour 'ceiling'. The natural setting of Buraida had one peculiarity; on the top of bare whale-back sand dunes were clumps of pines, or so they seemed to be seen from a distance; and this has left a picture in the mind of dark-green on light-coloured sand, the first thing that I saw coming into the town and last seen upon leaving it.

Before getting to the camp at Rumaihiya climbing an escarpment gave the trucks some trouble, and us some time to admire the great projecting slab edges of rock overhanging the plain from which we had ascended. Past the camp at Rumaihiya three days were needed to plough through more than a hundred miles of loose sand. It offered little of interest to a person who was not driving a car; a poor, sparse scrub grew on the sand, even a few flowering plants such as a minute white scabious, but of wild life only colonies of large, green, dragon-like lizards, called in Arabic *dhabb*, that fled to their burrows, and in doing so held horizontally stiff a long, notched tail. All the way from Buraida to Dhahran seemed to me to be intensely boring.

By now we were in a hurry to leave Arabia. Personally I felt that a few days of comfort would not come amiss, that it would be a

Overleaf:
45. Hail, Arabia: The Emir's Palace and Government Buildings (Detail)

desirable change to sleep in a bed, drink fresh water, eat something different from bully and biscuits, to have enough cigarettes, above all to enjoy the privacy of a room and the comfort of an easy-chair. And, only twenty miles of the sea separated us from some of these normal, everyday comforts: "I wish I were coming with you, Sir," said the driver of our car.

The sea trip to Bahrein had to be made in a launch operated by a motor and aided by a sail, a combination of driving forces which in a strong wind ensures as much pitching and tossing as an unseaworthy person can want. As I climbed onto the cabin roof and clung on there for three nasty hours I looked back at Arabia, a low strip of sand, and wondered if I should be able ever to return. I knew that I had seen only a very little of the secretive life of that harsh land.

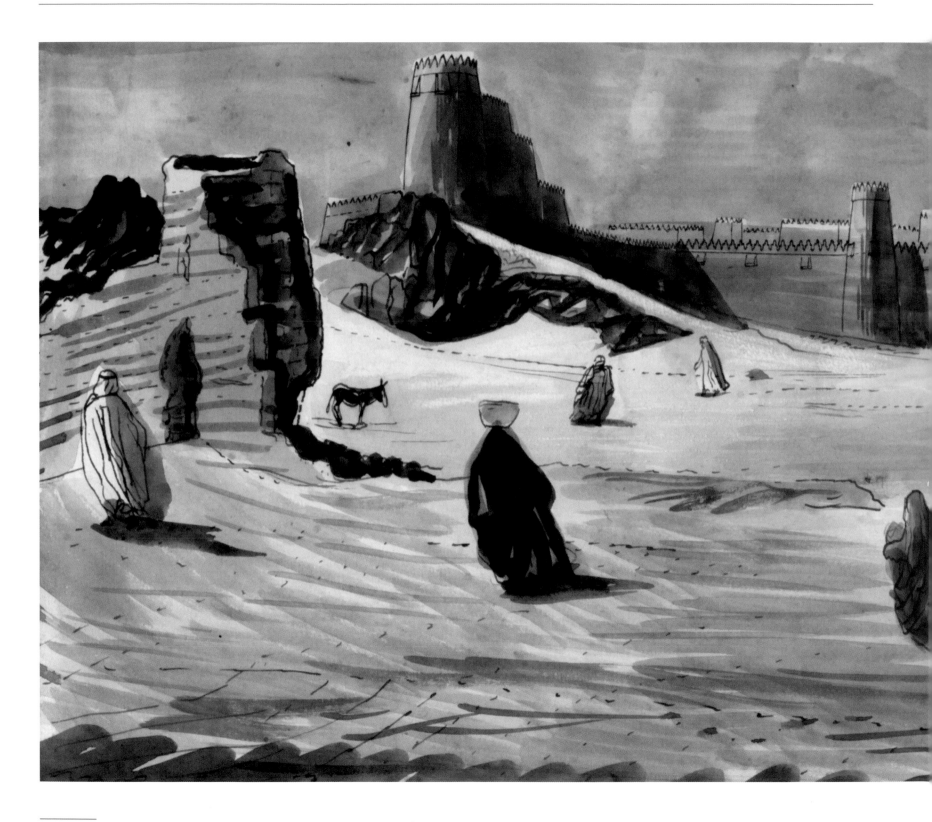

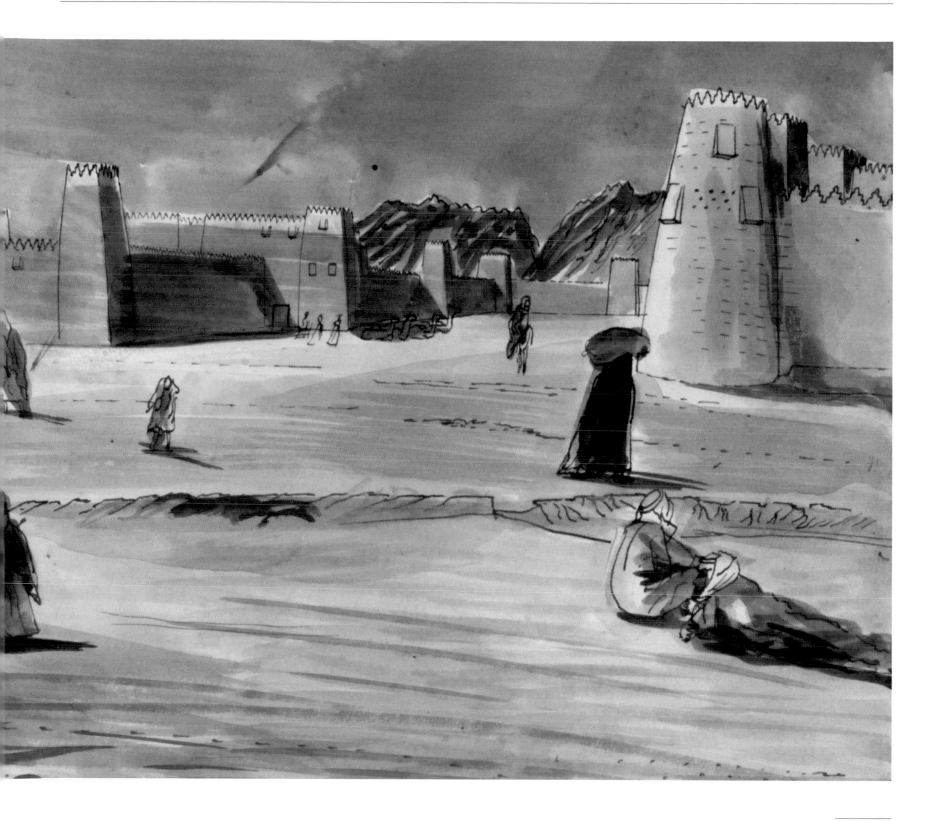

# ILLUSTRATIONS

1. Sheikh Shadid Sahib: Chief of the village of Mahsud, 1943. Watercolour on paper, 384 mm x 495 mm. IWM ART LD 4102

2. Rabiah, Karim, Khagiza: wife, son and niece of Sheikh Shadid Sahib, 1943. Watercolour on paper, 393 mm x 505 mm. IWM ART LD 4103

3. Mahomoud Khan and his son, Ahmed Khan: Chief of the village of Meriwan, 1943. Watercolour on paper, 384 mm x 498 mm. IWM ART LD 4104

4. Kurdish Chiefs at an Officers' Mess, 1943. Watercolour on paper, 384 mm x 495 mm. IWM ART LD 4105

5. Penjwin: View of the Leave Camp, 1943. Watercolour on paper, 384 mm x 993 mm. IWM ART LD 4097

6. Sulaimaniyah: a party of Kurds in national dress, 1943. Watercolour on paper, 384 mm x 495 mm. IWM ART LD 4107

7. Menelik's Palace; The Old Gebbi. On the right is the Emperor Haile Selassie's former study, 1941. Chalk, ink, watercolour on paper, 463 mm x 1162 mm. IWM ART LD 1801

8. The Showboat at Baghdad, 1944. Watercolour on paper, 660 mm x 1005 mm. Government Art Collection No.129

9. Amadia: A view of the town and of the camp of the Assyrian Levies, 1943. Watercolour on paper, 384 mm x 492 mm. IWM ART LD 4112

10. Amadia: the Priest Yusef and an Officer of the Assyrian Levies, 1943. Watercolour on paper, 384 mm x 495 mm. IWM ART LD 4113

11. Balad Sinjar: A view of the town, 1943. Watercolour on paper, 384 mm x 495 mm. IWM ART LD 4109

12. Baghdad: A View of the River Tigris and of the Camp of the Hygiene Section, an Indian Unit, 1943. Watercolour on paper, 431 mm x 774 mm. IWM ART LD 4114

13. Baghdad: Kurdish Levies, 1943. Watercolour on paper, 394 mm x 502 mm. IWM ART LD 4116

14. Baghdad: Kurdish Levies in a Barrack Room, 1943. Watercolour on paper, 384 mm x 495 mm. IWM ART LD 4117

15. Baghdad: Kurdish Levies; on the left a man in ceremonial dress, and by him an Orderly Sergeant, 1943. Watercolour on paper, 384 mm x 498 mm. IWM ART LD 4118

16a. Baghdad: An Illustration of Iraqi Policemen's Uniforms, 1943. Watercolour on paper, 501 mm x 385 mm. IWM ART LD 4119

16b. Baghdad: An Illustration of Iraqi Policemen's Uniforms, 1943.

Watercolour on paper, 497 mm x 385 mm. IWM ART LD 4120

16c. Baghdad: An Illustration of Iraqi Policemen's Uniforms, 1943. Watercolour on paper, 501 mm x 390 mm. IWM ART LD 4121

17a. Baghdad: An Illustration of Iraqi Firemen's Uniforms, 1943. Watercolour on paper, 495 mm x 385 mm. IWM ART LD 4122

17b. Baghdad: An Illustration of Iraqi Firemen's Uniforms, 1943. Watercolour on paper, 495 mm x 385 mm. IWM ART LD 4123

17c. Baghdad: An Illustration of Iraqi Firemen's Uniforms, 1943. Watercolour on paper, 501 mm x 385 mm. IWM ART LD 4124

18. A Creek in Sheikh Muzhir al-Gassid's Section of the Hatcham Tribe Territory, 1944. Watercolour on paper, 393 mm x 508 mm. IWM ART LD 4545

19. A Kurd from Ruwandiz: Sayid Mohammed Saddiq Taha, a Deputy, 1943. Watercolour on paper, 381 mm x 492 mm. IWM ART LD 4126

20. Hassan Mirza: son of Mirza Mohammed, 1943. Watercolour on paper, 384 mm x 565 mm. IWM ART LD 4131

21. Sergeant Horne, 1943. Watercolour on paper, 384 mm x 504 mm. IWM ART LD 4127

22. Sheikh Sharif al-Hafi, ND. Ink on paper, 394 mm x 507 mm. IWM ART LD 4560

23. Four of Sheikh Haji Maqtuf's sons, ND. Ink on paper, 369 mm x 509 mm. IWM ART LD 4558

24. A Coffee-man in the Settled Tribe Area, 1944. Watercolour on paper, 393 mm x 508 mm. IWM ART LD 4568

25. Ahwad Abdullah, Son of Abdulla the Coffee-man, 1943. Watercolour on paper, 384 mm x 561 mm. IWM ART LD 4129

26. An Iraqi Jew: Yusef Haim Shamell, a carpenter, 1943. Watercolour on paper, 390 mm x 570 mm. IWM ART LD 4130

27. The Chief Guide at Jebel Selma Camp with Corporal Winn and Corporal Jamal, 1944. Watercolour on paper, 393 mm x 501 mm. IWM ART LD 4251

28. Bedouin, 1944. Watercolour on paper, 393 mm x 501 mm. IWM ART LD 4253

29. Sheikh Muzhir al-Gassid of the Hatcham Tribe, 1944. Watercolour on paper, 393 mm x 508 mm. IWM ART LD 4547

30. Interior of Sheikh Muzhir al-Gassid's Mudhif, 1944. Watercolour on paper, 393 mm x 508 mm. IWM ART LD 4546

31. Sheikh Raisan al-Gassid, brother of Sheikh Muzhir al-Gassid,

1944. Watercolour on paper, 393 mm x 508 mm.
IWM ART LD 4548

32. Sheikh Haji Farhud al-Fandi, Hatcham Tribe, Preparing to Entertain, 1944. Watercolour on paper, 393 mm x 508 mm. IWM ART LD 4550

33. Mohammed bin Abdul Asis ibn Mardi, Emir of El Khobar, Dhahran, Dammam, Qatif and Jubail, 1944. Watercolour on paper, 389 mm x 498 mm. IWM ART LD 4258

34. Sheikh Haji Khaiyun al-Ubaid, paramount Sheikh of the 'Ubudah Tribe, 1944. Watercolour on paper, 393 mm x 508 mm. IWM ART LD 4563

35. Murad: one of the younger sons of Sheikh Haji Farhud, and the Sheikh's bodyguard, 1944. Watercolour on paper, 384 mm x 508 mm. IWM ART LD 4552

36. Sheikh Hammuda al-Muzai'il, 1944. Watercolour on paper, 393 mm x 508 mm. IWM ART LD 4555

37. A Majlis of the Sheikhs of the Southern Desert held by Major CSJ Berkeley: the local Political Adviser, 1944. Watercolour on paper, 393 mm x 508 mm. IWM ART LD 4569

38. Sheikh Haji Farhud al-Fandi of the Hatcham Tribe, 1944. Watercolour on paper, 393 mm x 508 mm. IWM ART LD 4553
39. Sheikh Wabdan al-Sa'dun and his brother Jabir, 1944. Watercolour on paper, 393 mm x 508 mm. IWM ART LD 4566

40. Three armed Muntafiq women, 1944. Watercolour on paper, 393 mm x 508 mm. IWM ART LD 4570

41. Aid To Russia: trucks on the road to Teheran crossing the Paitak Pass, 1944. Watercolour on paper, 393 mm x 1019 mm. IWM ART LD 4397

42. Aid To Russia: The rail-head at Khanagin, Iraq, 1944. Watercolour on paper, 393 mm x 514 mm. IWM ART LD 4399

43. Two of Sheikh Haji Khaiyun's servants, 1944. Watercolour on paper, 393 mm x 508 mm. IWM ART LD 4564

44. Sayid Abdul Husain, Sayid Hamud and Sayid Mohammed of the Hassuna Tribe, Iraq 1944, 1944. Watercolour on paper, 393 mm x 508 mm. IWM ART LD 4567

45. Hail, Arabia: The Emir's Palace and Government Buildings, 1944. Watercolour on paper, 389 mm x 501 mm. IWM ART LD 4243

# FRY ART GALLERY

The Fry Art Gallery is a public gallery unique in being totally devoted to displaying the work of Edward Bawden and the other artists of repute who gathered in the Essex village of Great Bardfield between 1930 and 1970. These included Eric Ravilious, Michael Rothenstein, RA John Aldridge RA, Kenneth Rowntree, Bernard Cheese, George Chapman, Sheila Robinson, Walter Hoyle, John Norris Wood, Stanley Clifford Smith, Audrey Cruddas, and Marianne Straub. It also shows work of other artists who lived in north west Essex at the same time – Michael Ayrton, Isabel Lambert, Robert Colquhoun, Robert McBryde – and in the nearby town of Saffron Walden, to the present day.

The North West Essex Collection comprises over 1700 works, including archive material, and offers a resource for researchers. The gallery is a fully accredited museum, managed and run by volunteers in the Fry Art Gallery Society, a registered charity.

Situated on the approach pathway to Bridge End Garden, in Castle Street, Saffron Walden the gallery is open free of charge annually between Easter Sunday and the last Sunday in October on Tuesday, Friday, Saturday and Sunday afternoons, between 2–5 pm, and on Bank Holiday afternoons during this period. Four public car parks are situated nearby. Parties out of hours can be accommodated for a small charge.

For further information on the changing exhibitions programme, or to join the mailing list (£5 pa) please either ring 01799 513779, consult www.fryartgallery.org or write to the Fry Art Gallery, Castle Street, Saffron Walden, Essex CB10 1BD